Philip Henry Gosse

Philip Henry Gosse

Science and Art in *Letters from Alabama* and *Entomologia Alabamensis*

Gary R. Mullen and Taylor D. Littleton

Foreword by Bonnie MacEwan and Marilyn Laufer

A publication of the Auburn University Libraries,

the Jule Collins Smith Museum of Fine Art at Auburn University,

and

The University of Alabama Press, Tuscaloosa

The University of Alabama Press
Tuscaloosa, Alabama 35487-0380
All rights reserved
Printed in China

Designer: Michele Myatt Quinn
Typeface: Adobe Garamond Pro

All plates are full-color, actual-size reproductions
of the original watercolors.

∞

The paper on which this book is printed meets the minimum
requirements of American National Standard for Information
Sciences-Permanence of Paper for Printed Library Materials, ANSI
Z39.48-1984.

Library of Congress Cataloging-in-Publication Data

Mullen, Gary R. (Gary Richard)
Philip Henry Gosse: science and art in Letters from Alabama and
Entomologia albamensis / Gary R. Mullen and Taylor D. Littleton.
p. cm.
Includes bibliographical references.
ISBN 978-0-8173-1708-9 (cloth: alk. paper) 1. Natural history
illustration—Alabama—History—19th cnetury. 2. Gosse, Philip
Heny, 1810–1888. Letters from Alabama. 3. Gosse, Philip Henry,
1810–1888. Entomologia alabamensis. 4. Insects—Alabama.
5. Wildlowers—Alabama. 6. Natural history illustrators—Great
Britain—Biography. I. Littleton, Taylor. II. Title.
QH31.G6M85 2010
595.709761'022—dc22 2010001032

CONTENTS

FOREWORD

It is with great pleasure that we present this volume, which serves as the Auburn University Libraries' ceremonial three-millionth volume and represents the first collaborative endeavor between the Jule Collins Smith Museum of Fine Art and Auburn University Libraries. This is the first complete publication of *Entomologia Alabamensis,* the sketchbook created by Philip Henry Gosse in 1838 during his residence in Dallas County, Alabama, and marks the bicentennial of Gosse's birthday.

Many have assisted in the development and completion of this project. Gary R. Mullen has worked tirelessly to bring Philip Henry Gosse and his work in Alabama to light. He first facilitated the production of the color transparencies created from the original watercolors in the British Library, which are now a treasured part of Special Collections and Archives in the Auburn University Libraries. His research and writing on Gosse informs this volume, as does Taylor D. Littleton's thoughtful examination. Both authors provided support, enthusiasm, and scholarship through their collaborative essays.

Dwayne Cox, head of Special Collections and Archives, worked with the libraries' technology staff, led by Aaron Trehub, to prepare the digital images and reproduce the prints for the original exhibition at the museum that led to the idea for this publication. Beth

Nicol worked diligently to prepare the final images. The JCSM staff, Scott Bishop, Daniel S. Neil, and Janet Guynn were instrumental in the creation of the original exhibition. Dennis Harper, curator of collections and exhibitions, provided editorial expertise for this text.

Special thanks to Provost Mary Ellen Mazey and Associate Provost Emmett Winn. We also gratefully acknowledge the Draughon family, the Caroline Marshall Draughon Library Bequest, and the late Susan Philips whose funds made this project possible. Our special thanks goes to the British Library for facilitating our request to reproduce Gosse's magnificent images.

We thank each other for the opportunity to undertake an innovative project and use it as an opportunity to strengthen the partnership between the museum and the libraries, our professional relationship, and above all our friendship. Finally, we thank our families for their patience as we both added another major project to the long list of demands on our time.

BONNIE MACEWAN, Dean of Libraries, Auburn University

MARILYN LAUFER, Ph.D., Director, Jule Collins Smith Museum of Fine Art at Auburn University

ACKNOWLEDGMENTS

We wish to thank the following entomologists for their assistance in identifying, or confirming, the insect species in Gosse's watercolors and for providing current taxonomic names: Richard Brown, Terry Schiefer, and JoVonn Hill, Mississippi State University; Lance Durden, Georgia Southern University; David Wagner, University of Connecticut; Charles Ray, Wayne Clark, and Timothy Nafziger, Auburn University. Thanks are also extended to Caroline Dean, Opelika, Alabama, and Curtis Hansen, Auburn University, for their help in identification of the wildflowers and other plants in the Gosse paintings. For their assistance to Gary Mullen in microscopically examining Gosse's depictions of insects in *Entomologia Terra Novae,* for the purpose of studying his miniature-painting techniques, the following individuals at the Library and Archives, Canadian Museum of Nature, Ottawa, are gratefully acknowledged: Ted Sypniewski, acquisitions and serials officer; Luci Cipera, conservator; and Jean-Marc Gagnon, collection manager of invertebrates.

Two individuals who deserve special recognition are C. Steven Murphree, Belmont University, Nashville, and Jennifer Gosse, Thatcham, UK, great granddaughter of Philip Henry Gosse. Murphree, while a doctoral student in entomology at Auburn University working with Gary Mullen, played a key role in locating Gosse's *Entomologia Alabamenis* in Jennifer Gosse's possession and was instrumental in obtaining the color positive transparencies of forty-eight of the forty-nine insect watercolors purchased by Auburn University Libraries in 1993. This was all made possible by the gracious cooperation of Jennifer Gosse in arranging to have the watercolors reproduced at the British Library. After placing *Entomologia Alabamensis* on loan to the British Library in 1992, she donated the Alabama watercolors in 2007 to the British Library, where they are now a permanent part of the manuscripts collection.

Finally, we wish to thank Elizabeth Lundey, who has assisted Dr. Littleton on this and many other research projects as well as Dean Bonnie MacEwan of the Auburn University Libraries and Dr. Marilyn Laufer of the Jule Collins Smith Museum of Fine Art at Auburn University, who were instrumental in making this publication possible.

GARY R. MULLEN, Professor of Entomology Emeritus, Auburn University

TAYLOR D. LITTLETON, Mosley Professor of Science and Humanities Emeritus, Auburn University

Philip Henry Gosse

Science and Art in *Letters from Alabama* and *Entomologia Alabamensis*

Philip Henry Gosse, naturalist, writer, and artist, was born in Worcester, England, on April 6, 1810, the second of four children to Thomas Gosse (1765–1844) and Hannah Best Gosse (1780–1860). The family moved to the commercial port of Poole, Dorsetshire, when Philip Henry was two years old. Thomas Gosse earned a meager income as an itinerant painter of miniature portraits, walking the countryside of southern England, often ten or eleven months out of the year, seeking commissions for his service. With Thomas gone most of the time and Hannah left to raise the children largely on her own, Philip Henry grew up under frugal conditions, with limited opportunities for an education. At an early age his father instilled in him an appreciation for literature, and he became an avid reader. Other than attending a day school as a youngster, his only formal instruction was two years at boarding school, where he delved into classical literature and learned the rudiments of Greek and Latin.

As a young boy, Gosse became intrigued by the marine animals that flourished in the tidal pools bordering the harbor at Poole. He enjoyed nothing more than exploring the seashore, with its diversity of interesting and colorful creatures. His interest in nature was fostered by his favorite aunt, Susan Bell, herself keenly interested in science, including the insects and flowers found along the roadsides, in gardens, and in the fields and woodlands surrounding Poole. She taught him the importance of carefully observing, recording one's findings, and learning all one could about nature and science. It was at this early age that Gosse was instilled with the excitement of discovery and a fascination with even the smallest of animals.

Philip Henry's father had received formal training in art at the Royal Academy in London. Among his instructors was the renowned portrait artist Joshua Reynolds, serving at the time as president. It was from their father that both Philip Henry and his older brother, William, learned the basic techniques of using watercolors and oils, and notably the art of painting in miniature. William went on to become an accomplished artist himself, producing sketches, oils, and watercolors of a variety of subjects, including plants and flowers, landscapes, and places where he lived or visited.

Philip Henry, on the other hand, showed little interest in portraits or landscapes. Instead, as a child, he preferred to sketch animals, copying illustrations from books on natural history and other published materi-

als. As he grew into his teenage years, he found that the art of miniature painting lent itself particularly well to preparing illustrations of marine organisms, butterflies, and the array of insects and other invertebrates that captured his attention. It enabled him to reproduce his subjects in life size, depicting them in increasing detail as he continued to improve his technique. With these skills learned as a child and with no formal instruction other than what he learned from his father, Philip Henry Gosse went on to produce perhaps the finest illustrations of insects and marine organisms in the nineteenth century.

At the age of fifteen, in order to support himself and to supplement the family's irregular income, Gosse took a job as a junior clerk with the mercantile firm of George Garland and Sons, at Poole. The focus of this commercial operation was the shipping trade with Newfoundland and the importation of cod and sealskins. After working there for two years, Gosse was offered a clerk's position at a counting house at Carbonear, Newfoundland. He left his home and family in 1827, at the age of seventeen, to sail across the North Atlantic, having signed an agreement to work there for six years as an indentured clerk. In this setting at Carbonear, his passion for natural history and entomology blossomed.

The year 1832 marked a major turning point in Gosse's life. In early May he purchased a copy of Adams's *Essays on the Microscope* at an auction of books from the personal library of a Wesleyan minister at the nearby town of Harbour Grace.[1] The book, published in 1797, was largely devoted to entomology and provided detailed instructions for collecting and preserving insects. Inspired by this volume, Gosse "enthusi-astically resolved forthwith to collect insects . . . and commenced as an entomologist in earnest."[2] He was twenty-two years old at the time.

Gosse began collecting insects, conducting simple experiments, recording his observations, and preparing detailed color drawings of many of the specimens. Intrigued by the details that he observed when his specimens were magnified, he constructed his own magnifying glass, fashioned from a lens that he mounted in a hand-carved bone holder. While in Newfoundland, he began keeping an entomological journal.[3] According to his son, Edmund, writing shortly after his father's death, Gosse considered 1832 to be "in several respects the most remarkable year in his life," adding that "he commenced that serious and decisive devotion to scientific natural history which henceforth was his central occupation."[4]

About this same time Gosse developed a strong spiritual leaning, largely influenced by George Jaques and his wife Ann, two devoted Christians and members of the Wesleyan Society at Carbonear. This relationship led to Gosse himself later joining the Wesleyan Society and acquiring a religious fervor that would continue to grow in the years that followed. After reading an extensive collection of his father's correspondence from this period, Edmund wrote: "In 1832 Philip Gosse, suddenly and consciously, became a naturalist and a Christian."[5] From that point forward, he never ceased to be awed by the beauty, the symmetry, and the most minute structural details of the natural world, revealed in even the smallest of God's creatures.

During the summer of the following year, Gosse began to compile what he titled *Entomologia Terrae*

FIG 1. Gosse's artist sketchbook *Entomologia Terrae Novae*, in which he illustrated his Newfoundland insects. It is similar in size and appearance to the sketchbook containing his watercolors of Alabama insects, *Entomologia Alabamensis*. (Photo by G. R. Mullen, Courtesy of Library and Archives, Canadian Museum of Nature, Ottawa)

Novae, the entomology of Newfoundland, his first serious venture as a young naturalist. This began as a sketchbook in which he illustrated, primarily in watercolor, more than 230 species of insects that he collected. The drawings were supplemented by careful notes and observations that he recorded in his entomological journal. The sketchbook measures 19.5 x 17 cm (7¹¹⁄₁₆ x 6¹¹⁄₁₆ in), with marble-patterned paperboard covers and 70 unlined pages (Fig. 1). For many of the species, particularly the butterflies and moths, he painted not only the adults but also their respective larvae and pupae. Together these species represent 12 orders and 63 families of insects. Gosse

envisioned one day publishing a book on Newfoundland insects, illustrated with his own original drawings. Although the manuscript that he was later to complete has been lost and was never published, the sketchbook has survived and is deposited at the Library and Archives Canada Preservation Centre at Gatineau, Quebec.[6]

Gosse's figures for *Entomologia Terrae Novae* capture in intimate and exquisite detail the diversity of insects, large and small, which he collected in the vicinity of Carbonear, primarily during the summers of 1834 and 1835. They provide excellent examples of the skill he had acquired at this early point in his life,

depicting with great accuracy the complex pattern of veins in the wings of dragonflies, the intricate color patterns of moths and butterflies, and even individual hairs and spines on the body and legs of insects, as observed through his microscope. Also included are figures of caterpillars and pupae of butterflies and moths, which he reared in order to observe their metamorphosis and to obtain pristine adult specimens from which to prepare his illustrations. His desire was to use, whenever possible, only live or freshly killed specimens for representing the perfection and what he deemed the splendor of the Divine creation.

Entomologia Terrae Novae documents the significant progress that Gosse made while at Carbonear in refining his artistic techniques and documenting the life of his insects (e.g., feeding as caterpillars on foliage, and as adult butterflies visiting flowers or resting on plants). Perhaps most revealing is the success he

achieved with stippling to show in beautiful detail the colorful wing patterns of butterflies, such as the black swallowtail (Fig. 2). As early as his mid-twenties, Philip Henry Gosse had become an accomplished illustrator, combining his talent for miniature painting with his keen eye and commitment to scientific accuracy.

Although the spring of 1833 marked the end of his six years of indentured service at Carbonear, Gosse continued his employment at the counting house for two more years before deciding to leave Newfoundland. Increased tension between Protestants and Catholics, and growing political clashes between English Loyalists and the predominantly Irish population of Newfoundland at that time were significant factors that influenced his decision. Advertisements by the British American Land Company for land opportunities in the Eastern Townships of Lower Canada, what is today Quebec, were appearing in the local

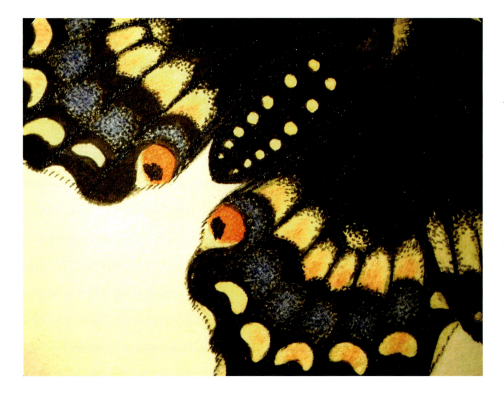

FIG 2. Enlargement of black swallowtail butterfly (*Papilio polyxenes*) from *Entomologia Terrae Novae*, showing Gosse's use of stippling to depict details of color pattern and texture of the posterior abdomen, with two rows of yellow spots, and the hind wings. (Photo by G. R. Mullen; Courtesy of Library and Archives, Canadian Museum of Nature, Ottawa)

media, offering cheap farmland and the expectation of productive harvests to entice immigrants to settle the region. Lured by the promise of prosperity, Gosse and his close friends the Jaques decided to move to Canada. There they jointly purchased a farm of 110 acres in the township of Compton, located on the Coaticook River in Sherbrooke County, north of the Vermont border.

Taking with him his insect cabinet, along with butterfly eggs, caterpillars, and chrysalides, Gosse arrived at Compton in the summer of 1835. He was immediately enthralled by the beautiful weather, the surrounding forests and swamps, and the diversity of butterflies flitting about the open fields. Writing to a friend a few months later, he rejoiced, "I am now merry as a cricket all day long."[7] He continued to collect insects and to work on his manuscript for *Entomologia Terrae Novae* as a welcomed diversion from the labor-intensive farm work. To supplement his income, he found employment with the local government schools during the winter months, providing him with his first experience as a teacher. As time passed, he became disillusioned with farming, unable to afford to hire field hands and repeatedly failing to return a decent profit from his labors. Disheartened by frozen crops, loneliness, and the lack of intellectual interaction, and troubled by rheumatism and a general deterioration of his health, Gosse became increasingly discouraged and depressed. Soon thereafter, he resolved to leave Canada and to pursue opportunities farther south.

In February 1838, Gosse wrote a letter to an acquaintance in Philadelphia, expressing his intent to travel to South Carolina or Georgia to seek employ-

ment as a schoolteacher. "I understand persons of education are in demand there, both in mercantile and academical situations. I believe, however, that I shall take Philadelphia in my course, and if anything can be done there, I shall not proceed further."[8] A few weeks later he left Compton, en route overland by wagon, south through Vermont to Albany, New York. Among his meager possessions, he took with him his insect cabinet containing hundreds of dried, pinned treasures that he had collected in Newfoundland and Canada. To his dismay, the specimens were badly damaged, many virtually destroyed, as the pins were shaken loose from the wooden bottoms of the drawers due to the jolting wagon ride over frozen, rutted roads. Adding to this devastating experience, Gosse was forced to leave the cabinet and its contents at Burlington, Vermont, when the stagecoach driver refused to let him board with it. From Albany, he took a steamboat down the Hudson River to New York City, continuing on by rail to Philadelphia, arriving there near the end of March.

In Philadelphia he immediately visited the Academy of Science, the center of American natural historians in the early part of the nineteenth century. There he was introduced to several distinguished men of science, including the zoologist-artist Titian Peale, botanist Thomas Nuttall, and conchologist Timothy Conrad, an authority on fossil shells. It is the latter to whom we are indebted for Gosse finding his way to Alabama. Conrad had earlier made several trips to Alabama to collect marine shells in Monroe County, in the rich fossil bluffs overlooking the Alabama River near Claiborne. He offered Gosse the opportunity to travel to Alabama to collect fossils for him and to ship

them back to Philadelphia. He also provided Gosse with a letter of introduction to a planter near Claiborne, in the hope that Gosse might find work there as a schoolteacher to help support himself financially. Finding no alternative prospects of employment in Philadelphia, Gosse boarded a small schooner in mid-April for the month-long voyage to Mobile.

On May 14, 1838, Philip Henry Gosse (Fig. 3) entered Mobile Bay aboard the *White Oak*, virtually penniless and uncertain of what lay ahead. The following day he found himself making his way up the Alabama River as a passenger aboard the packet steamer *Farmer*, en route to Claiborne. On board he met the Honorable Judge Reuben Saffold, Alabama's first Supreme Court justice, who had recently retired from the bench and who owned a plantation in Dallas County. When he learned that Gosse was looking for work as a teacher, he persuaded him to forego disembarking at Claiborne and to continue upriver to Dallas County and the community of Pleasant Hill. Saffold and a small group of other planters in the area were themselves seeking a schoolmaster and were in the process of constructing a log schoolhouse. Gosse accepted Saffold's offer of a one-year contract to teach the children of several plantation families.

While living in Alabama, Gosse experienced perhaps the most formative period of his life. It was there that he honed his talents as a descriptive biologist, perfected his artistic skills, and bolstered enough self-confidence to persuade himself that he could become a successful naturalist. During his daily walks to and from the schoolhouse, a distance of two miles from where he was boarding, Gosse collected insects. He had a particular fascination for butterflies, observing

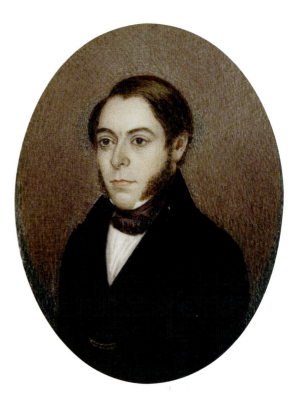

FIG 3. Philip Henry Gosse, age twenty-nine. Portrait miniature by his brother William Gosse, watercolor on ivory, 1839, the year following Philip Henry's departure from Alabama to return to England. (Courtesy of the National Portrait Gallery, London)

their behavior and meticulously recording notes in his entomological journal. While in Dallas County, he produced in his sketchbook some forty-nine pages of beautifully detailed watercolors of Alabama insects, which he collectively titled *Entomologia Alabamensis.*

Gosse's stay in Alabama proved to be shorter than anticipated, lasting less than eight months, from mid-May to the end of December 1838. A major factor contributing to Gosse's decision to leave was the "disquieting elements . . . of the institution of slavery."[9] He became physically ill at times upon witnessing the treatment of laborers and was tormented by de-

liberate nighttime lashings of female slaves outside his window. In his son's, words, it "would make him almost sick with distress and impotent anger, and I have heard him describe how he had tried to stuff up his ears to deaden the sound of the agonizing cries which marked the conventional progress of this very peculiar 'domestic institution.' . . . It sickened him, and it had much to do with his abrupt departure."[10] Gosse became increasingly reluctant to express his opinions on the subject for fear of retaliation, and was particularly uneasy after discovering that someone had entered his room and rummaged through his personal effects, even opening and reading his correspondence. Stressed both mentally and physically, he made increasingly fewer entries in his scientific journal, until ceasing altogether in early October. As Edmund noted, "For the last three months of his stay in Alabama, there scarcely exists any record, except for a private diary which is painful reading."[11]

His spirit was lifted in mid-December after he was persuaded to attend a quarterly meeting of the Methodist Society at Selma. Upon returning to Pleasant Hill, he felt the calling to be a Wesleyan minister and to stay in Alabama, "convinced that he was to spend his life there preaching and visiting."[12] However, for reasons that remain unclear, he suddenly changed his mind and decided to return immediately to England. Within days he had packed his belongings, bid farewell to the Saffolds and other friends, and bought passage on a steamer to Mobile, departing from there on his return voyage to England on December 31, 1838. About that time, or shortly thereafter, he made the conscious decision to devote his life to writing books on natural history and religious subjects, with

the intent of selling them as his principal means of a livelihood.

In 1848, Gosse married Emily Bowes; their only child, Edmund William Gosse, became a well-known biographer and literary critic in England. He is perhaps best known for his book *Father and Son* (1907) about his relationship with his father. Following the death of Emily in 1857, Philip Gosse married Eliza Brightwen in 1860. The family lived at St. Marychurch, South Devonshire, where Gosse devoted much of his time to writing.

He wrote more than 40 books and 270 scientific and religious articles, including *An Introduction to Zoology* (1844) and *Natural History* (1848–1854), a series that included separate volumes on mollusks, fishes, reptiles, birds, and mammals, and *A Handbook to the Marine Aquarium* (1855). In 1857, he published his most controversial book, *Omphalos*, in which he challenged the validity of evolution and presented his case for what today is called creationism. His most significant scientific works, however, were in marine biology and taxonomy, notably *Actinologia Britannica: A History of the British Sea-Anemones and Corals* (1858–1860) and *The Rotifera* (with C. T. Hudson) on marine rotifers (1886, 1889).

In recognition of his scientific contributions, Gosse was elected Associate of the Linnaean Society (1850) and a Fellow of the Royal Society, London (1856). His greatest accomplishment, however, was as a popular writer of science for the general public. He is credited with producing the first illustrated field guide (on marine organisms) to help the nonspecialist identify and learn about animals. In addition, Gosse is acknowledged for his invention of one

of the first saltwater aquariums in which to observe and study marine organisms, and designed the first public aquarium, which opened in London in 1858. Gosse died at St. Marychurch, Devon, on August 23, 1888, at the age of seventy-eight and was buried at nearby Torquay Cemetery.

¿

Gosse's many distinctions, especially his undoubted influence on the rising public awareness of science and its possibilities, may suggest that he occupies a minor but, to use one of his favorite locutions, a not unworthy place in the lifetime of his century. A retrospective validation of that place may be that several of his works are currently being reprinted.[13] His verbal and graphic documentation of behaviors in the natural world were, in their descriptive precision, arguably unmatched among his peers. Yet, to Gosse, these phenomena always found their origin and meaning in the providential power of the God of Genesis. "We observe facts," he wrote in the midst of his first publication, *The Canadian Naturalist*, "but when we presume to inquire why these things are so, we are baffled and repulsed . . . the primary cause must be referred to the Father who, we may be assured, appoints the seasons, and watches over the welfare of the meanest objects of His creation."[14]

This almost contradictory union of vigorous investigation of nature's secrets and an unyielding Christian determinism made Gosse unable to accommodate the new biology of the Victorian century. His first biographer—his son, Edmund Gosse—observed that he was indeed a man of "singular character" but

"was less in sympathy with the literary and scientific movement of our age than, perhaps, any writer or observer of equal distinction."[15] This judgment, rendered toward the close of that age, following Philip Henry Gosse's death in 1880, was written with the confidence that by then the startling news had been intellectually assimilated that the earth and its natural populations had emerged from a vast history of patient mutability. The elder Gosse who, the son wrote, had contributed so much to the "sum of exact knowledge" may well have had "at the same time so little in common with his contemporaries."

Yet Gosse's achievements notwithstanding, he surely was one of thousands then whose theological principles resisted the concept of evolutionary change. But whatever cultural suggestion Philip Henry Gosse's career may hold for us, reading the two prefaces to that career—*The Canadian Naturalist* (1840) and *Letters from Alabama* (1859)—hardly seems to justify the casual description in a standard contemporary reference of our own time: "eminent zoologist and fanatical fundamentalist Christian."[16] For in those prefaces, no zealous intrusions compromise the written voice of a nineteenth-century naturalist whose unpretentious inquiries, supported by a richness of detail, strive to clarify those mysteries of nature hidden from the unobservant eye.

One of his finest legacies is contained in the masterpiece of scientific art, Gosse's *Entomologia Alabamensis*—published for the first time as a complete collection in the present volume—where Gosse's watercolor paintings of insects and wildflowers, illuminated in their intricate beauty, remind us still after 170 years of the awesome creation we inhabit.

Letters from Alabama

During the late spring of 1838, Philip Henry Gosse began entries in a journal describing his new life and his scientific field observations in the Pleasant Hill community of Dallas County, Alabama. These notations would form the basis of the second volume conceived by Gosse during the 1830s, although they would not emerge in book form, under the title *Letters from Alabama*, until twenty-one years later. The first volume, entitled *The Canadian Naturalist*, would be published in January 1840, and Gosse probably had much of its content well in hand when he began his Alabama residence. This work, like its successor, would record a decisive period in Gosse's career, and in its literary style, organization, and comprehensive view of natural history would provide a model for *Letters from Alabama*.

The continuum in each of these books of a strong autobiographical resonance began in the harsh Canadian winter of 1837–1838 when Gosse resolved to define his life in two directions: first, to leave Lower Canada, where his three years of farming and property ownership had been a lonely and dismal failure, and move southward toward the possibility of some kind of remunerative teaching position that would, second, sustain his effort to become a professional author. He had already taught on occasion in the small community school, for which his intellectual quickness, his knowledge of Greek and Latin, together with his counting-house experience and his considerable reading of scientific literature, were more than adequate. But vastly more important, during his entire eleven-year Newfoundland-Canadian residence he had accumulated a detailed journalistic summary of

his extensive field observations of plant and animal life, doubtless recorded as a pleasurable, yet serious, relief from accounting ledgers and the drudgery of ax and plow. And, once he had begun to draw on this written treasure in the composition of his first publication, he could express the euphoria of finally, at the age of thirty, securing a literary sense of himself in the wondrous world of nature: "Perhaps one of the chief pleasures of natural history, especially entomology, is the perpetual novelty and variety we find in it . . . the endless diversity of habits, locality, structure, form, colour, to be found in insects is such a source of pleasure as effectively prevents us from feeling weariness or melancholy. . . . It seems almost a contradiction in terms, for a naturalist to be in low spirits."[17]

The Canadian Naturalist would predict the course of Gosse's long and prolific career: his commitment to investigate, as he wrote on its concluding page, "the mysteries of nature . . . hidden from the unobservant . . . but continually disclosed to him who walks through the world with an open eye." To Gosse, such a commitment would involve him in both a descriptive and artistic conception of natural history, suggested in both the title page and preface of this work. Its subtitle, *A Series of Conversations on the Natural History of Lower Canada*, was followed by the author's name, "P. H. Gosse," and a proud display of his unassuming credentials: "Corresponding Member of both the Natural History Society of Montreal, and of the Literary and Historical Society of Quebec," to which he had already contributed papers. Yet, importantly, what seems to be both a dedicatory quotation and an idea of the conversational format is taken from Gilbert White: "Every kingdom, every province, should

have its own monographer." Gosse probably felt that this source would be self-evident, for White's *The Natural History of Selborne*, first published in 1788, had already moved through several editions and was well-known both to scientists and the general public. Darwin himself had read it as a young man.

White's work consists of many letters written to two fellow naturalists over a period of fourteen years. The quotation selected by Gosse seems to justify his own singular task as "monographer," that is serving his readership as an agent of exposition. And though he does not quote the rest of the passage (from a letter of October 8, 1770), its import forms the model for *The Canadian Naturalist*—and, subsequently, for *Letters from Alabama* as well—"Men that undertake only one district are much more likely to advance natural knowledge than those that grasp at more than they can possibly be acquainted with."[18] White, in the opening letter of his series, describes in detail the specific geographical location of Selborne parish in Hampshire, including the parishes and counties surrounding it and the latitude. Similarly Gosse, in his preface to *The Canadian Naturalist*, describes in like manner the location of his Compton village: the name of the county, the riverside setting, its location "very near the angle formed by a line drawn south from Quebec, and one drawn east from Montreal," and its twenty-mile distance from the Vermont border. Thus his confined, carefully delineated Canadian district is the "immediate neighborhood" wherein Gosse's observations have been made, just as Gilbert White's Selborne parish, and more particularly his vicarage garden, became a microcosmic setting for the revelations of natural history.

White's epistolary reflections were those matured over a lifetime, whereas Gosse's were only two or three years old. But Gosse's easy familiarity with the masterpiece of his great predecessor suggests that he also held a conception of "natural history" that set aside the eighteenth-century passion for classification and exactitude. He states in the preface—with the proper humility of an unpublished author—that his remoteness in the "far-off wilds of the west" has not made it possible for him to know the systems and arrangements studiously and with patient perseverance compiled by "men of enlarged minds." Instead he offers almost a complete enclosure of his residential space: its climate, geography, characteristic plants and timber, history and tall tales, bird migrations, and trivia of human and seasonal adaptations.

It would be, he writes in the preface, "a kind of Canadian Natural Calendar," with its framework being conversations between a fictional father and son as they walked the fields and forests around Compton Township. The title may also owe something to White, who, before *The Natural History of Selborne* (1788), had kept a "Garden Calendar" eventually published as *The Naturalist's Journal* and, in his final letter of June 25, 1787, had planned but not completed a "Natural History of the Twelve Months of the Year."[19] Gosse may have been influenced also by the principal and hugely popular poem of one of his favorite authors, William Cowper, whose "The Task" (1785) was partially organized on a plan of seasonal change, meandering rural walks, and discursive subjects. Edmund Gosse states that his father took the conversational form from a work by another prominent turn-of-the-century figure, Sir Humphry Davy

and his *Salmonia; or, Days of Fly Fishing* (1828), a dialogue in the Izaak Walton mode that also takes reflective and thoughtful turns away from its promised subject.[20]

Though both *The Canadian Naturalist* and *Letters from Alabama* were published in England, each was derived from Gosse's "open eye" American journals. Each also exhibits his wide reading in literary and scientific works, often adding a rich subtext to what he called the "woodland rambles" of the fictional father and son. Actually, he need not have apologized in the preface for the abruptness of transition between the episodes described; each is complete in itself and adequately maintains the image of impromptu encounters. However, it might be observed that both of these works seem to be conscious literary efforts, with carefully chosen examples Gosse wants to describe and analyze. He is, after all, wishing to capture the imagination of a Victorian readership. He wants them to know what he has experienced in this far-off province, whose natural history has become an integral part of his life. His contemplation of scenes in that history has, for him, reaffirmed the presence of "the great and glorious God," and he hopes that his own written recollections of these "calm delights" will have a similar effect on others.

Thus with the artless confidence that always seems to animate his writing about his field inquiries, he moves through the calendar framework with the conversational technique being little more than the son asking leading questions of the father. A February snowstorm leads to a lengthy discussion on how small snow crystals are formed on a cottage window; Gosse proceeds to illustrate their geometric shapes in one of his many woodcuts (Fig. 4), stating that such are overlooked except by "one accustomed to pry into the minutiae of creation." The month of May reminds him of the pestiferous clouds of mosquitoes that ravage rural households; and then, within his discursive pattern, he suggests that the two ramblers stop at one of his favorite spots, a bridge over a "placid river flowing in blackest shade beneath the tall overhanging woods on each side." He writes, "I love to stand here at this hour," and in one of his finest descriptive passages, quoting a poetic line from Shelley, he reflects on the ancient history of the place, the bridge itself being the only sign of civilization. The primitive wildness calls up his imaginative voice: "We seem to expect the face of the Huron to peep from the woods, or the canoe of the chivalrous Algonquin to dart round yonder point." And he proceeds to a multi-page discourse of the Indian presence and their life there, concluding with the oracular premise: "But the Indians are passing away." Both in Canada and the American states, he believes, "all the tribes will recede as the mighty power of white civilization pushes toward the Pacific." And he meditates, "A benevolent mind cannot contemplate the fate of the red man without a pang of regret for the harshness of his destiny." Even though this conclusion is colored by European colonialism: "That it is better for the world at large, that this vast continent should be peopled with civilized and Christian men," Gosse's contemplative and intrinsic feeling for the human dimension of natural history is impressive and will be expressed even more strongly in *Letters from Alabama*, which would follow nearly twenty years later.

The full text of *The Canadian Naturalist* provides

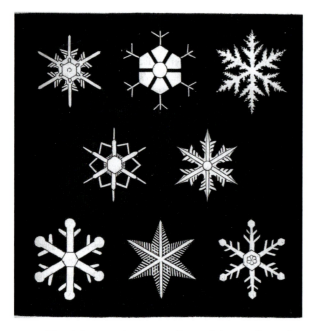

FIG 4. The delicate architecture of snowflakes, or "crystals of snow," captured by Gosse in his Canadian-winter woodcut. (*The Canadian Naturalist*, p. 27)

such evocative passages as the October Indian Summer transition to the hard clarity and "deathly stillness" of a November morning; interspersed are more prosaic accounts of the detailed composition of a beech tree trunk, the best wood for winter burning, and the threshing procedures of a farmer's September. And, as one would expect from this man who would always in his writing find a persistent interface between the human and the natural, he often manages to find what for him tended to be a lonely life silently reflected in nature's scenes. Thus, following a September discourse on the different migratory distances freshwater ducks and geese are capable of flying, he abruptly quotes several stanzas from William Cullen Bryant's well-known poem "To a Waterfowl" (1821), clearly implying the confidence that "he" who guides

their "certain flight" also "In the long way that I must tread alone, / Will lead my steps aright."

Gosse's consistent transfer of his perceptive observations in field and forest into providential terms would be modified by the time he came to compose *Letters from Alabama*. Still, given their occasional sermonizing character, it is certainly possible to place these early works of orderly assurance that, as he writes in musing about the disappearance of the Algonquin into the shadows of history, "Nature remains the same" into a contradictory relationship with the questing scientific spirit already on the verge of at least modifying this premise. Gosse, speculating on newly flowering buttercups in June, can conclude that despite their uselessness to man, since cattle don't like them, they "yet no doubt answer some purpose of utility in the great economy of Creation, and the chain would be imperfect without [them]." This reductive elaboration is even more evident in his extensive description of the emergence of the adult of a small wasp from the pupal stage, drawing itself through the slender petiole as the delicate pupal skin unexpectedly expands to permit the passage. To Gosse, such was illustrative of "creative design and forethought," a difficulty that the insect, insulated from the external world, had "never yet experienced" but had entered a new condition "for which it could not possibly have received any instructions." And from this latter phrase, a strangely ironic rejection of what would become to many contemporary scientists the idea of an immense evolutionary journey, he states that such a microscopic solution irresistibly validates "like the light of noon upon the open eye, that there was a contriver, an intelligent maker . . . and who is he but God?"

Reading this language so pervasive in the long history of the tension between faith and doubt, one may feel justified in placing the subject of Philip Henry Gosse within its early Victorian stages. Too, one might feel it necessary to find a balancing contemporary perspective that does not, in its view of natural history, attempt to guide our conclusions. One of Gosse's favorite authors, Sir Humphry Davy, professor of chemistry at The Royal Institution in London and a pioneer in the study of magnetism and chemical reactions, in a letter to a colleague earlier in the century also addressed the example of insect metamorphosis but in a tone of restraint and humility. The caterpillar, he wrote, in its transforming movement from an inert scaly mass seems unaware of its preparation for "the brilliancy of its future being . . . an inhabitant of the air." Against the visible transience of the physical world, he felt there is yet the lingering power of human intelligence even though we must recognize that however acquainted we feel with all the elements of matter "we cannot even guess at the cause of electricity or explain the laws of formation of the stones which fall from meteors."[21]

Gosse's commitment to the providential closure is, of course, at odds with Davy's spirit of open inquiry as to how the world works. That stance, which Gosse would never abandon in his writing, would question his otherwise engaging views of the meaning of natural history, but would seem not at all to impede the progress of his inventive genius, his significant contributions to "the sum of exact knowledge," or the value of his writings in popularizing the subject of science itself. One might even observe that these latter publications, in a strangely ironic way, may actu-ally have helped to hasten the average citizen's gradual acceptance of such challenges to the biblical view of the earth's history—and Gosse's own conception of unchanging Nature—as did Sir Charles Lyell's *Principles of Geology* (1830).

Were all this to argue for his unobtrusive yet specific identity in the crowded intellectual life of his time, Gosse's painting and drawing would bear witness to it. To Gosse, his art was a seamless extension of his writing and had been so from the beginning of his career. He wrote in the preface to *The Canadian Naturalist* that he himself had executed forty-one of the forty-four illustrations that appear in the book. Some of these, the more simple line drawings, for example, of the yellow trout-lily (Fig. 5) and elm tree, he may have completed during the long winter nights in Lower Canada, and possibly even some of the more complex colored drawings of native animals he thought his eventual readership might want to see: lynx, black wolf, and moose. It was this accumulation, together with his indispensible journals, that he took with him as he embarked down the majestic Hudson toward what Gosse hoped would be a new life, his eventual destination being Philadelphia, the center of art and science in America, where he might meet some of those "men of enlarged minds" whose work he had come to admire.

ح

As Gosse wrote in the preface to *The Canadian Naturalist*, "even now, the recollection of those pleasant scenes sheds forth a luster which gilds the edge of many a dark cloud." His retrospective feeling about

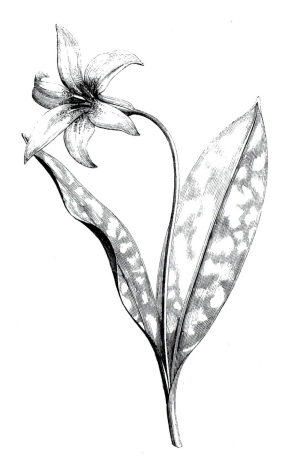

FIG 5. Yellow trout-lily (*Erythronium americanum* Ker Gawler), or what Gosse called 'yellow dog-tooth violet,' a member of the Lily family; he described it as having "a very elegant drooping flower, of a bright yellow"; woodcut from colored drawing Gosse made in Lower Canada. (*The Canadian Naturalist*, p. 124)

the emotional meaning of the Canadian experience is confirmed in the closing lines of "December;" and there is no reason to doubt his sincerity that the persona subsumed in the "wild woodland rambles" of the fictional father and son had become "wiser and better," its cheerfulness increased, its mind calmer and more elevated. The book, after all, was a celebration of his life there, and he could be justly proud that he

had been right in his hope that others would be reading about it.

The preface was dated from London, January 1840, almost exactly one year after Gosse had completed his third residence on the North American continent. During this period, he had also kept a journal, with its complementary artwork, and all of this too would have been taken on board ship as he returned to England. Foremost in his mind throughout 1839, of course, was securing a publisher for *The Canadian Naturalist*, and there is some evidence to indicate that at this time his plan to move forward in publishing the experiences recorded in the Alabama journal was uncertain.

In fact, the text of his first book, about his life in Canada, at times draws on the life that he lived, later, for eight months in Alabama. For example, he refers to the bird nest of a northern flicker, or yellowhammer, "once shown to me in Alabama," to the unidentifiable sound of the birdlike "saw whetter" and had "asked Mr. Titian Peale, the venerable Professor Nuttall, and other ornithologists of Philadelphia" about it; he recalls the cruelty of a technique of rabbit hunting and trapping, which he will repeat in *Letters from Alabama*; and also to be repeated there is a verbatim account of a tame deer that he "once saw in the State of Alabama." This latter descriptive passage of some 200 words is one of his finest, and Gosse's remembrance of the "large swimming black eye" and "the fairy lightness and elegance in its whole appearance, which make it the prettiest of the pets" obviously was for him a touching instance of the human kinships to be found in his view of natural history.

However, within the fictional construct of the

father-and-son walks in the fields around Compton Township, none of this has happened: he has not yet arrived in either Philadelphia or Alabama. Thus, such allusions subvert the chronology and geographical boundaries so carefully described in the preface to *The Canadian Naturalist*. This curious contradiction in a writer as exacting as Gosse may be explained in part that, as he completed in 1839 the text of the new book, he felt nothing was lost in using some of the Alabama journal entries since he did not have immediate plans to publish them. And perhaps he, or his publisher, felt that adding the Alabama references would widen and increase the interest of English readers in this beyond-the-Atlantic subject.

Obviously there are many affinities between *The Canadian Naturalist* and *Letters from Alabama*. But the one was written from a relatively recent perspective, the other composed in its final form some twenty years later. By then, Gosse had firmly established himself as a professional author, publishing over twenty-five books, some by the same London house, John Van Voorst, that printed *The Canadian Naturalist*, and others by the Society for the Preservation of Christian Knowledge. Many of these carried wood engravings, others colored illustrations done in the new lithographic process, such as the volumes on Jamaican ornithology (1849), and some had both English and American editions. A Fellow of the Royal Society since 1856, Gosse spoke, as it were, in his scientific, religious, and popular marine biology writings to multiple audiences, reaching still others in his occasional sermons and classes in seashore investigations in Devon.[22] Why here, at the height of his eminence, he decided to resurrect his journal notations and art-

work from Alabama may not be entirely clear, but Gosse was not one to waste an important stretch of time during his American years. He wanted, it seems, to write about and publish on every promising experiential or intellectual subject of interest to him, and he doubtless kept the Alabama material in mind as other publishing projects emerged. Even though *Letters from Alabama* was not published until 1859, he was looking for a publisher several years earlier and finally published a version in a periodical called *The Home Friend* (1855).

Letters from Alabama was slightly preceded by *Evenings at the Microscope*, also published in 1859, a work that illustrates Gosse's ability to share in a colloquial manner—but, he is careful to say, without sacrificing "the precision essential to science"—his knowledge of entomological wonders. Like *Letters from Alabama*, *Evenings at the Microscope* was also retrospective. Gosse states in the preface that many of the zoological marvels that the microscope reveals, especially to the young student researcher, had already appeared in his earlier publications but had been newly verified for this one. As always, his art extended his narratives, and he executed ninety-five woodcut illustrations, from hair fibers of cats and mice to the structure of a snail's eye, to the circulation in a frog's foot, almost all of them being "drawn on the wood direct from the microscope, at the same time as the respective descriptions were written." And the role he assumes is not dissimilar to that affected in both *The Canadian Naturalist* and *Letters from Alabama* as he shapes his technical descriptions "into the form of a series of imaginary conversations, or microscopical soirées, in which the author is supposed to act as the provider of

scientific entertainment and instruction to a circle of friends."

These descriptive passages are replete with language heightened by the naturalist's joy of discovering the spirited behaviors available to the "open eye": for example, in the chapter on "Zoophytes" in *Evenings at the Microscope*, "It is pleasant to go down to the shore on a bright natural morning at low water, when the tide has receded far . . . to penetrate where we have never ventured before, and to explore with a feeling of undefined awe the wild solitudes where the hollow sea growls, and the gray gull wails . . . under the shadow of the tall cliffs of limestone, to creep into low arching caves, and there to stoop and peer into the dark pools. . . . What microcosms are these rugged basins! How full of life all unsuspected by the rude stonecutter that daily trudges by them to and fro from his work in the marble quarry of the cliff above."[23] This is Gosse at his best, writing and drawing his way toward a celebration of that "perpetual novelty and variety" in natural history first commemorated years before in *The Canadian Naturalist*. He signed the preface to *Evenings at the Microscope* at Torquay in February, and dated the preface to *Letters from Alabama* only a few months later, from Torquay in July of 1859.

That year in Alabama was quite different from the 1838 recalled by Gosse in the *Letters*. The English readership among whom the book began to circulate would have been aware of the political volatility in the American South—reactions to the celebrated raid in October by John Brown at Harpers Ferry, Virginia, for example, and the secessionist rumors connected to the anxiety of a possible Abraham Lincoln election the next year. In Alabama, the legislature in No-

vember passed bills appropriating funds for defense and for the organization of several thousand men for a military corps.[24] However, any book appearing that year in England would have been subordinated to the publication amidst great wonder and consternation of Darwin's *The Origin of Species*.

In *Letters from Alabama*, Gosse is careful to point out both in title and preface his emphasis on natural history, especially its branch of entomology. As in *The Canadian Naturalist*, he addresses a dual audience: the English reader unfamiliar with the novelty of this remote "hilly region of Alabama" where Gosse lived for eight months and, with more confidence than in the earlier work, zoologists whose knowledge of American entomology could be strengthened by Gosse's observations. He arranges an epistolary format for the book within the structural calendar of the circling seasons, somewhat reminiscent of the *Natural History of Selborne* by Gilbert White, whom he references in the letter of September 20. The letters are addressed to an unnamed reader and seem designed to bridge the cultural distance between frontier Alabama and Victorian England, with the letter of June 1 being the best example among the eighteen others in addressing both a generalist and scientific audience.

Here, Gosse invites the recipient of the letters to become his companion for a typical day's experience. "But stay;" he writes, "suppose you just transport yourself (in imagination) to Alabama, and spend the day with me," and, meeting his guest at the gate of his residence, "Walk in; we are just going to breakfast, though it is but six o'clock." The account of the plentiful rural meal, "'Hold!' You say, 'What is hominy?' Ah! I forgot you were a stranger," with a full detail of

how such southern cookery as "waffles" are prepared is concluded with their departure: "No more? I fear novelty has taken away your appetite; but, however, if you have really done, we will be going. I will just get my butterfly net; I always carry it."

What follows, in a conversational mode that effectively transcends the occasionally artificial father-son dialogue in *The Canadian Naturalist*, is a fine illustration of Gosse's comprehensive sense of "natural history" in both its environmental and human forms, with the recorded observations as the two walk toward the schoolhouse seeming quite consonant in their variety. They first hear the song of the mockingbird, the "leader of the American orchestra"; then see the lizards, including the "scorpion," that rustle in the leaves on either side of the path; the voracious nature of black ants that tend to devour "my preserved specimens of insects"; multiple species of butterflies, the zebra swallowtail, for example (Fig. 6), all elaborately described, including the dusty-colored browns, which "resemble the meadow-butterflies of our own country"; they hear, first, the whistling sound and then see a cardinal grosbeak that has a nest close to the schoolhouse door, about six feet from the ground with two eggs "whitish, covered with brown spots." What follows is a pathway encounter with a tick, its painful bite and a physical description of two of its species; a sighting of a pair of wild turkeys, "the finest bird that America has produced," with a three-hundred-word account of how they may be trapped in a turkey pen, illustrated with a drawing; then, with the five o'clock ending of the school day, they walk homeward to the "garrulous" but "sweet sound" of turtledoves that remind them of the cuckoo in their own country, "so full

of summer and all its pleasant associations"; the sight of the flower called "Indian pink" is noted as valuable in medical botany; as they enter a small hardwood hollow, a barred owl flies "silent and ghost-like across our path"; and, emerging, they are treated to a gliding and swooping group of nighthawks whose rapid descent causes a booming report. As the two walk closer to home, they hear the negro field hands calling in the local hogs in a far-reaching, powerful, but almost musical, voice; the behavior of southern wild hogs is described, especially when hunted for sport or food. Supper being not ready, they walk in the garden where the early evening air is "loaded with perfume" and the fusion of odors from flower, field, and forest "throng upon our senses"; the mules are turned into the yard, the flower called "four o'clock" has opened into full bloom and has attracted the hawk moth, which becomes the subject of an extensive entomological lesson for the phantom companion, especially the appearance and function of the insect's proboscis, which in some of the more fully developed species "is a beautiful instance of the modification of a part to adapt it to altered circumstances." But their day together is ending, their investigations are set aside, and the companion is invited to "take a little supper," not what "we are accustomed to call tea," but for Americans the last meal of only three in the day; but, now, since the guest has "a long way to go tonight, you have need," writes the narrator, "to spur your Pegasus" on the return to England and "many thanks for your company."

Although the fictional English visitor does not often reappear, this whimsical litany of encounters, expressed in Gosse's heightened descriptive style that

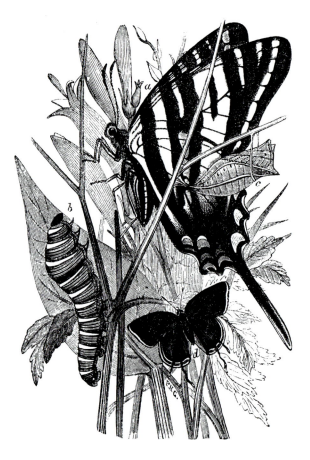

FIG 6. Zebra swallowtail (*Eurytides marcellus*), woodcut by Gosse. (a) "very handsome" adult, (b) caterpillar, and (c) chrysalis on Indian pink (*Spigelia marylandica*); (d) Red-banded hairstreak (*Calycopis cecrops*) at lower right. (*Letters from Alabama*, p. 52)

first appeared in *The Canadian Naturalist*, is replicated in almost all of the letters, ordered, one feels, as a mnemonic inscription of a transitional and undoubtedly lonely period in Gosse's scientific and literary life. Several years in its evolution, the text of the book assumed its final form with Gosse having less sense of urgency to publish, as was the case with his earlier Canadian experience. Thus here the authorial "I" becomes that of a genial and observant persona who

selects the episodes and interpretations that will identify the character of his Alabama experience. With an occasional exception, there is a certain tranquility in the recollections, and a passage in the letter of December 1 suggests how memory may have enhanced the accuracy of the journal notations. Gosse's remembrance of Canada is called up as he sees a migratory snowbird, which had been such a common sight in Canada, hopping about and sitting on every fence: "How slight a thing will touch the chords of sympathy! The smallest object, the faintest note, will sometimes awaken association with some distant scene or bygone time, and conjure up in a moment, all unexpected, a magic circle, which unlocks all the secret springs of the soul, and excites emotions and affections that had slept for months, or perhaps years! . . . The first time I saw it in these distant southern regions, it seemed like an old friend come to tell me of old familiar faces and to converse with me of old familiar scenes." This symbolic reclamation—here, of Canada in a memoir written about Alabama—is suggested often in the hundreds of episodes appearing on almost every page of *Letters from Alabama*: the descriptive sounds of the turtledove, for example—"something inexpressibly touching, soothing our spirits and calming us into unison with the peaceful quiet of nature." Such a serene phrase may have been composed years after the 1838 residence, or on a given evening after supper and the daily walk from the schoolhouse. But it is the "unison," the web of associations discovered within the human and natural world that gives *Letters from Alabama* its dominant character.

Don't "expect from me anything like a continuous narrative," he exclaims in the letter of July 1, protest-

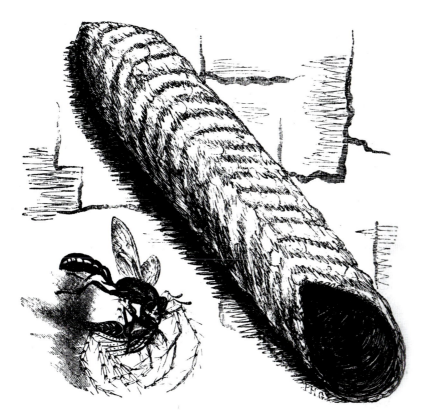

FIG 7. Organ-pipe mud dauber (*Trypoxylon clavatum*), woodcut of a female carrying a paralyzed green-lynx spider (*Peucetia viridans*) back to its tubular mud nest, as food for the wasp's larvae that will develop there. (*Letters from Alabama*, p. 244)

ing that his disjointed observations are only "peeps through Nature's keyhole at her recondite mysteries." Yet what a reader is continuously given is countless small narratives, miniature stories of the behavior of spiders, beetles, mud dauber wasps (Fig. 7), and moths, which are written down and more often than not visually reproduced. These are interwoven with other small narratives of his experiences with the inhabitants of Pleasant Hill, although, in keeping with the spirit of the book, he feels that solitude in nature is inevitably congenial, which is not always the case in human society. His schoolroom, "a funny little place" with its split-pine-board desks, is filled with urchins slow to conjugate verbs and who know little of what in crowded cities is thought worth knowing,

but "these boys of mine," he writes, read a language of the sounds and sights of the wilderness. He recounts several scenes in which they instruct him about local insects, until then foreign to his experience: the cicada, which he had always wanted to examine, and the "chameleon," or green anole, whose color-changing prowess he had thought "a mere fable."

The range of Gosse's emotions in his appraisals of what he saw as the Alabama character moves, as in the case of his "boys," from affection and respect to sympathy for those planter families caught in the inevitable summer droughts (letter of June 10), to amusement in his mock-heroic description of a night's horseback ritual of possum hunting (letter of August 15). He had already, as many nineteenth-century visi-

tors would do, noted the restlessness of the American character, its inability to sustain itself among the thousand amenities that the English "delight to accumulate around us, and which are so many links to enchain us to a given spot" (letter of July 3). And in the letters of July 15 and September 1, he astutely described those contradictory qualities that future writers of Southern fiction and history would also confirm: a generosity of hospitality (in torrid weather, "if a guest calls, the first offering of friendship is a glass of cold water" followed by "an immediate shout for water-melons"); but this must be placed against a hostility to alleged intrusion into considered assumptions and beliefs, and a fierce independence that often transcends the law and sustains beneath the surface of community a quarrelsome and reckless violence in human relationships.

In one of his earliest letters, that of May 20, Gosse described his initial walk from the river to his place of employment as lush with flowery vistas, the abundance of bird and animal life, and noted the "charm of absolute novelty that attended everything here." He regretted that he had not come earlier in the spring when "the gate of Eden is, as it were, re-opened." But he also saw then, for the first time, "negro slaves performing the labors of agriculture," and he was immediately revolted by their inhuman treatment. Within the fiction of the letters chronology, Gosse instinctively understood, by September, that the Eden whose grandeur and beauty had meant so much to his educational odyssey had been irretrievably corrupted by slavery, "a huge deadly serpent." Thus his unflagging honesty about the cultural boundaries of natural history obligated him, further in the letter of September

1, to abandon his usual persona of detached observer and directly express his feelings. The letter itself is only five pages long, in a text of over 300, and is a deliberate insertion, having nothing to do with the entomology of the preceding or following letters, or with his thematic calendar of seasons.

Gosse had firsthand knowledge of the cruelty intrinsic to the slavery system; Edmund Gosse states that his father witnessed some of the lashings of both men and women in his own residential community. Other horrors—repressive labor, the desperation of hunger, the use of night patrols and bloodhounds to capture runaways—he heard about through private conversations and through a kind of dreadful osmosis ("again in the September 1 letter, facts will ooze out"). England in 1832 had banned slavery in all of its provinces, and the condition had been condemned by prominent Victorians, Charles Dickens, for example, in his *American Notes* (1842).[25] But few voices would seem more authentic than Gosse's, given his time and place. In fact, one might wonder whether the September letter was composed after Gosse left Alabama since he states that "he dare not describe by letter" his knowledge, and he "is obliged to be very cautious" because "there is a very stern jealousy of a stranger's interference" or manifest curiosity about the condition. Moreover, if Edmund Gosse's further notation is accurate, his father had "unquestionable proof" that his belongings were searched and his letters examined. Whether Gosse's perceptions were written in 1838 or in some succeeding year before final publication, his judgments are no less perceptive: those engaged in the management of slavery and those who tolerate its continuance often experience a brutalization

of character; they live in a society increasingly on the edge, imprisoned in an economic condition absolutely dependent on a system of labor immorally riven with cruelty and human suffering; "the institution is doomed," he writes in the same letter, and when its certain end comes, "perhaps swiftly[,] . . . it can hardly be other than a terrible convulsion."

Gosse's oracular predictions, written well before the American Civil War, also included a belief that dangerous social and political disarray would occur once hundreds of thousands of slaves "uneducated . . . and smarting under a sense of accumulated wrongs" were emancipated. These attitudes and his hatred of the system helped to motivate his departure from Alabama, although his loneliness, lack of intellectual companionship, and perhaps longing for a domestic life were also relevant. He may have been little better off financially than when he arrived, but there is no indication that he ever considered making a permanent home outside of England, where the possibilities of publication lay. However, even as he was assembling his own journals and artwork toward the end of 1838, it is a minor, but arresting coincidence that the final volume of Audubon's *Birds of America* was being printed. Moreover, in 1838 Charles Darwin was also correlating his vast notebooks speculating on the nature of heredity, environment, and the emergence of new species for publication in 1839 as *A Journal of Researches into the Geology and Natural History of the Various Countries Visited by HMS Beagle*. And perhaps it is within this wider cultural context that the significance of Gosse's Alabama experience may be found.

He would, in succeeding years, correspond with Darwin about various botanical and entomological matters; and he knew Audubon's work, quoting in *The Canadian Naturalist* a verbatim account of his famous description in one of the ornithological biographies of the flight of millions of passenger pigeons.[26] Audubon had in fact, in 1837, immediately preceded Gosse in traveling into the Alabama frontier. It is coincidental that Audubon also witnessed an episode from a dark chapter in Southern history, writing to a fellow ornithologist that before boarding a steamer in Montgomery for the trip downriver to Mobile, he saw—actually not many miles from Gosse's Pleasant Hill—the roundup by state militia and U.S. soldiers of large groups of Creek Indian families during the last stages of the Indian Removal Program at the beginning of the infamous Trail of Tears: "their future and latter days," he wrote, "must be spent in the deepest of sorrows, affliction and perhaps even physical want."[27]

Gosse would never meet Audubon, but the art and writing of Audubon helps to illuminate that of Gosse. Both wrote about what they had already drawn and painted, their ecological descriptions being as precise as their illustrations of birds and insects. Nature art is a special kind, its object usually being to capture in line and color the reality of the specimen brought quickly to microscope or screen from the world in which it had lived. Although Gosse's colors in *Entomologia Alabamensis* will bear a proper comparison with the brilliant hues of Audubon's birds, his paintings could not accurately be named "scientific illustrations"; they were not, like Audubon's, intended for immediate publication and calculated to initiate something new in American art. However, they were much more than, in the words of Edmund Gosse, "the delight-

ful amusement of his leisure hours in the schoolhouse and at home,"[28] and he kept them privately for the rest of his life, perhaps recalling from time to time that his painting and writing almost always took place in the afternoon or evening since the heat under an Alabama sky made the cooler "morning hours . . . the only part of the day that can habitually be rendered effective to science" (letter of July 5).

During his years in Canada and Alabama, Gosse had little if any correspondence with the realistic forms of early American art, and yet the unpublished entomological masterpiece finds a kind of remote parallel with what has been described as the non-illusory literalness that pervades that artistic sensibility.[29] Given his ascetic turn and his conviction, expressed over and over, of God's operative hand in nature—"creative foresight"—Gosse seemed to regard his own artwork as a human, therefore imperfect, striving to capture the Divine reflection in the world he saw before him. Gosse rarely alludes to his own art, but in "February" of *The Canadian Naturalist* he refers to this conception in the translation of miniature technique, especially the practice of stippling, into the delineation of insects: "Look at a fine miniature painting," says the father to the son, and "even the most delicate production of human workmanship," when placed beneath a microscope, will be "seen to be made up of minute dots . . . uncouth blotches, coarse, and without form. . . . But examine the Divine handiwork," and the specimen itself under magnified power will exhibit in all its parts "faultless regularity and beauty." Yet despite what would be Gosse's expected disparagement of the image as opposed to the creation itself, his insect portraits in *Entomologia Alabamensis*, life-size, accu-

rate reproductions, "exquisitely drawn and colored," according to the son, may properly be compared to *Birds of America*, one of the greatest works of nature art in American history.

But even with his doctrinaire views, Gosse shares with Audubon and, indeed, with William Bartram, the pioneering traveler who preceded them both in describing and drawing the Alabama River landscape, a verbal sense of the naturalist's sacred duty. In Gosse's metaphor, all three of them walked through the world with an open eye, confirming in an exalted language that would transcend the Darwinian revolution an ideal conception of America's relationship with nature. The messages sent forward by these writers and artists assert that relationship as an interrelated web of the human and natural condition, one gently demanding wonder and reverence. To William Bartram, this world is "a glorious apartment of the boundless palace of the sovereign Creator . . . a glorious display of the Almighty hand." Audubon could write that in his study of American birds, "admiring the manifestations of the glorious perfections of their Omnipotent Creator . . . have I sought to search out the things which have been hidden since the creation of this wondrous world, or seen only by the naked Indian."[30] And Gosse, in the letter of July 1, musing as always on the providential power allowing, for example, a concentration amidst a "blossomed field" of millions of insects, each pursuing a separate pathway of existence, "I have often thought that no one can appreciate the grandeur, the sublimity of this sentiment . . . like the devout naturalist."

Written in a relatively confined—but no less unique—American space of time and geography, the

content of *Letters from Alabama* allows us to place Gosse within the great tradition of nature writing. Such writing, however personalized its artistic style, almost always sends us messages—like letters—affirming the place in nature's web of such details as chameleon behavior or the habits of swallowtail butterflies. These are among the letters we most like to receive, a sharing between writer and reader of timeless things we readers did not understand that we needed to know. Keeping us aware of our critical—even sacred—connection to the strange grandeur of this invisible pattern is the special province of the naturalist, a province quietly defined in the work of Philip Henry Gosse. He was a temporary visitor in our distant past, but his letters speak to us still in their spirit of generosity: like the account on May 20, 1838, of his first "woodland ramble," as he climbed the steep hill from the winding river, "If it afford you half as much pleasure to read it as it afforded me to walk it, I shall feel well repaid."

Entomologia Alabamensis

In reflecting on his father's experiences in Alabama, Edmund Gosse wrote in 1890:

> There remains, as the principal memento of these months in the south, still unpublished, a quarto volume entitled *Entomologia Alabamensis*, containing two hundred and thirty-three figures of insects, exquisitely drawn and colored, the delightful amusement of his leisure hours in the schoolhouse and at home. His powers as a zoological artist were now at their height. He had been trained in the school of the miniature painters, and he developed and adapted to the portraiture of insects the procedure of these artists. His figures are accurate reproductions, in size, colour, and form, to the minutest band and speck, of what he saw before him, the effect being gained by a laborious process of stippling with pure and brilliant pigments. It has always been acknowledged, by naturalists who have seen the originals of his coloured figures, that he has had no rival in the exactitude of his illustrations. They lost a great deal whenever they came to be published, from the imperfection of such reproducing processes as were known in Philip Gosse's day. The *Entomologia Alabamensis*, however, is one of those collections of his paintings which remain unissued, and it is possible that it may yet be presented to the scientific world by one of the brilliant methods of reproduction recently invented.[31]

Gosse's watercolors of Alabama insects were done in a sketchbook, similar in size and format to the sketchbook in which he painted his Newfoundland insects. However, to protect the volume, his grandson Philip Gosse had the sketchbook rebound by Sangorski and Sutcliffe of London sometime in the early 1930s. The rebound volume measures 20.5 x 18 x 1.7 cm (ca 8 x 7 x 0.7 in). As viewed today, it bears a red cover with "ENTOMOLOGIA ALABAMENSIS—P.H. GOSSE—1838" embossed in gold. Affixed to the inside of the front cover is a bookplate with "EX LIBRIS Philip Gosse." Gosse's forty-nine watercolors appear on the right-hand side as viewed when the sketchbook is opened (Fig. 8). On the back of each page are handwritten notations in pencil recording the common and scientific names of the insects depicted, together with brief comments on coloration, host plants, and sources that he used to make his identifications after returning to England.

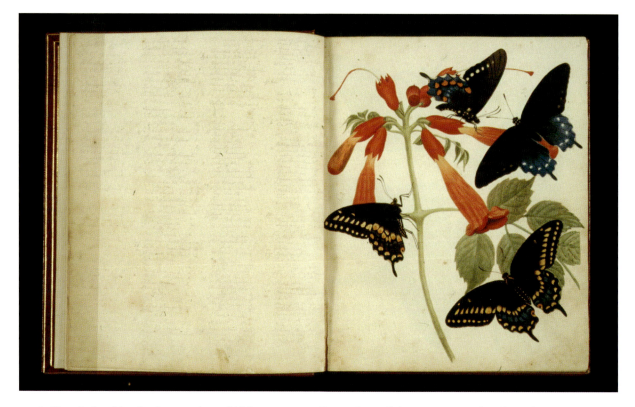

FIG 8. Gosse's sketchbook of watercolors of Alabama insects, *Entomologia Alabamensis*, opened to show the pipevine swallowtail (*Battus philenor*) and black swallowtail (*Papilio polyxenes*) on trumpet creeper (*Campsis radicans*). (Courtesy of the British Library, London)

The 233 figures of insects are presented in forty-nine composite paintings, representing ten taxonomic orders. Thirty-eight of the watercolors are devoted to the order Lepidoptera, the butterflies and moths, reflecting Gosse's particular delight in this colorful and diverse group. Including their caterpillars and pupae, the lepidopterans alone comprise three-quarters of all the figures. The remaining nine orders of insects, with the number of figures for each, are: Coleoptera (beetles)—thirteen; Hymenoptera (ants, wasps, bees)—ten; Phasmida (walkingsticks)—seven; Odonata (damselflies and dragonflies)—six; Diptera (true flies)—six; Hemiptera (cicadas, stink bugs, kiss-ing bugs, and other piercing-sucking insects)—five; Neuroptera (antlions, whose larvae are called doodle-bugs, and owlflies)—four; Orthoptera (grasshoppers, crickets, and katydids)—three; and Mantodea (praying mantises)—three.

Although butterflies and moths were his favorite subjects, he did not neglect the other groups of insects that he also observed and collected in Dallas County. The most visually eye-catching of the non-lepidopteran works is one devoted exclusively to beetles (Pl. 48), in which Gosse illustrates thirteen species, including some of the largest, showiest beetles in the southeastern United States. He likewise reserved separate

sheets for illustrating the dragonflies and damselflies (Odonata, Pls. 31, 32 and 33), praying mantids (Mantodea, Pl. 44), and walkingsticks, or stick insects (Phasmida, Pls. 43 and 46). The remaining insects, representing twenty-four species in five orders (Neuroptera, Orthoptera, Hemiptera, Hymenoptera, and Diptera), are relegated to two composite works depicting various species, loosely grouped taxonomically (Pls. 47 and 49). All are shown as individual specimens in either dorsal or lateral view against a plain background.

A cursory look at the watercolors reveals several different arrangements of the figures. Some appear neatly arrayed, as though displayed as pinned specimens in a museum drawer (e.g., Pls. 25 and 27), while others appear as individual specimens suspended in midair, with a blank background and no context (e.g., Pls. 7, 9, and 21). In some cases only a single specimen is depicted (Pls. 23 and 24), whereas in others there are as many as a dozen or more (e.g., Pls. 47 and 49). Although the exception, Gosse has captured glimpses of behavior and ecological associations of certain insects, as in the case of a dung beetle rolling a dung ball (Pl. 48), a mud dauber carrying a paralyzed spider to provide as food for her larval offspring in the tubular mud nest she has just constructed (Pl. 45), caterpillars feeding on leaves of their preferred host plants (Pls. 35, 39, 40 and 41), a potter wasp with its distinctive spherical, urnlike mud nest in which her offspring develop (Pl. 47), and moths and butterflies delicately sipping nectar, either in flight (Pls. 4 and 19) or alighting on flowers (Pls. 8 and 11). In other instances he documents the metamorphosis of moths and butterflies, showing the caterpillar and corresponding pupae and cocoons for a wide variety of species (Pls. 37, 38, 39, and 40), many of which also are depicted as adults in some of Gosse's other watercolors. He even shows different color forms, or morphs, of certain insects that he observed; these include the pink form of a katydid (Pl. 49) and both the typical yellow form of the eastern tiger swallowtail (Pl. 3) and less common black form (Pl. 2).

Virtually all of Gosse's insects are shown in life size, a further effort on his part to capture as closely as possible the specimens he observed. This poses a particular challenge in illustrating subjects as small as insects, and especially in showing the finer structural details. Gosse was a master at both. His extraordinary success was made possible by a unique combination of factors that characterize Gosse and his work: his keen observant eye and attention to detail; his meticulous examination of specimens through a microscope; his spiritual fervor in striving to present his subjects in all their perfection; and, above all, his exceptional talent painting in miniature. The more his insect images are enlarged, the more the details are revealed—including individual setae and spines on the legs (e.g., praying mantises [Pl. 44]; beetles [Pl. 48]), antennal characters (e.g., Polyphemus moth [Pl. 23]), the complexity of wing veins (e.g., dragonflies [Pl. 31]), and intricate color patterns (e.g., Eastern comma and Question mark [Pl. 10], and American lady [Pl. 12]). Gosse's watercolors of Alabama insects, together with other works he was to produce during his long career, remain unmatched as the finest scientific illustrations of invertebrates in the nineteenth century.

It is only on closer inspection, however, that one begins to appreciate the full measure of Gosse's artis-

tic talent and penchant for maximizing the scientific content of his works. He is not content to show just the upper view and colorful identifying wing patterns of the butterflies and moths he collected; with the same care and attention to detail, Gosse shows the color pattern of the underside of the wings for each species depicted. He does this by rendering a pair of figures for each species, one in dorsal view and the other in ventral view, thereby maximizing the morphological information for each taxon (e.g., Pls. 5, 6, and 7). In other cases, he represents specimens with their wings spread, as one does with pinned museum specimens, to reveal the coloration and details of the otherwise hidden hind wings when the insect is not in flight; for example, the praying mantises (Pl. 44), lubber grasshopper (Pl. 42), and most moths (e.g., Pls. 21–28) and butterflies (e.g., Pls. 3, 5 and 6). Often the full view of a given species is provided, particularly in the case of the butterflies, by showing it resting on a plant with the wings folded dorsally over the abdomen to show details of the underside, and with another specimen in flight, typically hovering near the plant, to display the upper view of both the fore and hind wings (e.g., Pls. 1, 4, 10, and 16).

The most striking of the paintings, however, are the adult butterflies and moths visiting wildflowers. The plants are depicted with the same meticulous care and attention to detail that Gosse gives his insects. He captures with graceful precision not only the beautiful flowering structures but also the stems and leaves, providing both an artistic and natural backdrop. In some cases the choice of flower is a typical plant species on which Gosse observed the particular butterfly or moth feeding, such as the pearl crescent on False

foxglove (Pl. 8) and the red-spotted purple on Indianshot (Pl. 13). In other cases, the choice appears to be a plant form that allowed him to conveniently depict multiple lepidopterans on a single plant, as in the seven species of skippers flitting about pencilflower (Pl. 18), five species of hairstreaks, azures, and blues on Yellow Indiangrass (Pl. 16), and the palamedes swallowtail and eastern tiger swallowtail on Bermuda grass (Pl. 3). He even goes to the effort, in some cases, of showing the various stages of flowering, including the unopened bud, partially opened petals, flower in full bloom, and spent flower (Pls. 1 and 8).

The culmination of Gosse's artistic talent is especially reflected in four of his watercolors of Alabama insects, two of butterflies (Pls. 1 and 14) and two of moths (Pls. 19 and 20). They are true works of art, extending well beyond scientific illustrations. The composition, balance, richness of color, and vibrant quality of the subject matter combine to evoke aesthetic pleasure in the viewer. These particular watercolors stand in a category by themselves, capturing in exquisite simplicity and elegance that which Gosse strived to achieve throughout his life—an appreciation of nature's splendor, ever waiting to be revealed to the interested observer, even in the "lower" and smallest forms of living organisms.

Many of Gosse's Alabama watercolors are not finished compositions. One obvious example is his painting of dragonflies in which two of the three figures lack wings, except for a penciled outline of their shape (Pl. 32). The watercolors of the epione underwing and bella moth (Pl. 30) and the coral hairstreak (Pl. 17) likewise are incomplete, giving the appearance of isolated figures arbitrarily positioned on the

page. Space presumably was left for adding other figures later. Other watercolors are significantly more complex, depicting groups of closely related species of butterflies in pairs, showing both the upper and lower sides of the wings (e.g., sulphurs and yellows [Pl. 9]; satyrs [Pl. 15]). At first glance they, too, appear to be somewhat randomly arranged. However, on close inspection one can see faint pencil lines denoting the vertical stems and lateral branches or leaves of plants that were yet to be added to the composition. As in the more complete watercolors with wildflowers as a backdrop, the butterflies with their wings folded over their backs, showing the color patterns on the underside of the wings, can be envisioned resting on the plant; those shown from above with their wings spread are butterflies in flight, hovering about the invisible plant in the background. This is most easily discerned in the case of the sulphurs and yellows (Pl. 9); if one projects an imaginary line running vertically between the butterflies with folded wings, the main stem of the plant that Gosse envisioned in the final work will be evident.

These incomplete images reveal three notable points about Gosse's technique. First, before ever touching brush to paper, he fully conceptualized the composition of his intended finished work, determining the precise location and orientation of each specimen to be illustrated. Second, he sketched in pencil the outline of his intended figures, carefully depicting them in actual size. Third, he painted the insects and then, only after they were completed, added the plant or other object in the background. The latter point is clearly demonstrated in his watercolors of caterpillars and pupae (Pls. 35, 39, 40, and 41). While the caterpillars are fully rendered, the leaves on which the caterpillars feed exist as preliminary sketches. Yet, even as sketches, the leaves reveal Gosse's meticulous observation and detailing.

Gosse's superb illustrations, both scientifically and artistically, can be attributed in large part to his mastery of two important skills as a miniature painter: mixing of pigments and his use of stippling. With the assistance of family and friends back in England, he was able to obtain the art supplies he needed, which could be purchased from "artists' colour shops" in London and other art centers and cities of the early nineteenth century.[32] These included a wide selection of finely ground pigments and binder in the form of dry cakes, with which he was able to prepare virtually any tint he chose by carefully mixing and applying them, in separate layers, to achieve the desired colors and tones.[33] In this way he captured perfectly the delicate greens of the praying mantis (Pl. 44) and luna moth (Pl. 24), the earthy browns of the satyrs (Pl. 15), the striking scarlet of the hind wings of underwing moths (Pl. 28) and the lubber grasshopper (Pl. 42), the subtle differences in oranges and orange-browns of the monarch (Pl. 6), the blues and blue-blacks of the dark form of the eastern tiger swallowtail (Pl. 2) and red-spotted purple (Pl. 13), the delicate yellows of the sulphur butterflies (Pl. 9) and wildflowers (Pls. 8 and 12), the silvery spots on the underside of the wings of the gulf fritillary (Pl. 7), and the complex pattern of rose, browns, and grays of the American lady (Pl. 12). By doing so, he shares with the viewer the full natural beauty, and vitality, of the live specimens he observed. One exception, perhaps, is the bright blue on the hind wings of the pipevine swallowtail (Pl. 1),

which does not quite as faithfully depict the unusual iridescent blue, and often bluish-green coloration, characteristic of this species.

As noted by Charles Day in his 1852 instruction manual for miniature painters, stippling was "inseparable" from miniature painting. It was used primarily to fill "little inequalities" with color, make backgrounds and tints lighter or darker, and soften the edges of facial features, clouds, and other objects. As Day put it, "This is, in fact, the whole art of stippling."[34] Gosse, however, took stippling to a whole new level in miniature painting by adapting the technique for his scientific illustrations of insects, using it to show minute details, intricate color patterns, and even the textural quality of scales on the wings of butterflies and moths. As his son observed, he had "a miraculous exactitude in rendering shades of colour and minute peculiarities of form and marking."[35] Gosse's consummate stippling skill is best revealed by examining his color drawings under magnification through a microscope or other means of enlargement (Fig. 2).

Another significant aspect of the Gosse watercolors is one that is easily overlooked by the casual viewer. Even in his finest composite illustrations of butterflies and moths, with multiple species flitting about or resting on beautiful wildflowers, Gosse makes no allusions to deep pictorial space. He likewise minimizes the use of modeling to create three-dimensional views of his subjects. Nonetheless, a number of his insect portraits do exhibit a certain volumetric quality, notably some of the beetles (Pl. 48) and some of the caterpillars and pupae (e.g., Pls. 38 and 39). This is accomplished in part with judicious highlights, also used to capture the luster of smooth, dark cuticle, as in the case of certain beetles (Pl. 48), the mud dauber wasp carrying a spider (Pl. 45), and the lubber grasshopper (Pl. 42).

Unfortunately the vivid colors and luminosity that characterize watercolor miniatures tend to be lost when the paintings are reproduced in printed form. Gosse's insect watercolors are no exception. This was an "acute disappointment" to Gosse throughout much of his life because of the technical limitations involved in mechanically reproducing the color illustrations for his published works. There was a striking loss "in freshness, brilliancy, and justice of the tone" between the reproductions and the original watercolor drawings.[36] Today the exquisite details, the vibrant quality, and the vitality of Gosse's miniatures can be best appreciated when viewed in natural sunlight or as digitized images brightly projected on a screen.

It is our good fortune that Gosse's original insect watercolors have been beautifully preserved to this day, some 172 years after his brief sojourn in the Black Belt region of Dallas County, Alabama, protected all these years in a bound volume which he aptly titled *Entomologia Alabamensis*.

Notes

1. Edmund Gosse, *The Life of Philip Henry Gosse, F.R.S.* (London: Kegan Paul, Trench, Trübner and Co., 1890), 70. All subsequent references to the biographical record are taken from this edition. A more comprehensive biography is by Ann Thwaite, *Glimpses of the Wonderful: The Life of Philip Henry Gosse* (London: Faber and Faber, Ltd., 2002). Gosse purchased a copy of George Adams Jr.'s *Essays on the*

Microscope (London, 1787) at the auction of a private book collection in Harbour Grace, Newfoundland, in 1832, when he was twenty-two years old.

2. Edmund Gosse, *Life*, 70–71.

3. Ibid., 71.

4. Ibid., 70.

5. Ibid., 71.

6. Philip Henry Gosse's sketchbook of insect watercolors entitled *Entomologia Terrae Novae* was given to the National Museum of Canada by his grandson Philip Gosse in 1952. Philip Henry Gosse, *Entomologia Terrae Novae* (unpublished sketchbook, Library and Archives, MS OCJ. G67, Canadian Museum of Nature, Ottawa).

7. Edmund Gosse, *Life*, 93.

8. Ibid., 104–5.

9. Ibid., 142.

10. Ibid., 143.

11. Ibid.

12. Ibid., 145–46.

13. Some of P. H. Gosse's books on natural history that have been reprinted in recent years are: *The Ocean* (1856; repr. Ann Arbor: University of Michigan University Library, The Michigan Historical Reprint Series, 2005) and *Evenings at the Microscope; or, Researches Among the Minuter Organs and Forms of Animal Life* (1860; repr. Ann Arbor: University of Michigan University Library, The Michigan Historical Reprint Series, 2005); *Omphalos: An Attempt to Untie the Geological Knot* (1857; repr. Woodbridge, CT: Ox Box Press, 1998); *Letters from Alabama: Chiefly Relating to Natural History* (1859; repr. Tuscaloosa: University of Alabama Press, The Library of Alabama Classics, 1993); *The Romance of Natural History* (1863; repr. New York: Cosimo Classics, 2007); *A Year at the Shore* (1865; repr. Landisville, PA: Coachwhip Publications, 2008). Other titles are available from Kessinger Publishing's Rare Reprints (www.kessinger.net), including: *The Canadian Naturalist*, 1840; *An Introduction to Zoology*, 1844; *The Birds of Jamaica*, 1847; *A Handbook to the Marine Aquarium*, 1856; *Tenby: A Seaside Holiday*, 1856; *Life in Its Lower, Intermediate, and Higher Forms: Or Manifestations of the Divine Wisdom in the Natural History of Animals*, 1857.

14. Philip Henry Gosse, *The Canadian Naturalist* (London: John Van Voorst, 1840), 187–88. All subsequent references to this source are taken from this edition. Citations from *Letters from Alabama* are taken from the 1859 edition, published by Morgan and Chase, London.

15. Edmund Gosse, *Life*, vii–viii.

16. "Gosse, Edmund," *The Oxford Companion to English Literature,* ed. Margaret Drabble, 5th ed. (New York: Oxford University Press, 1985), 405.

17. P. H. Gosse, *The Canadian Naturalist*, 226.

18. Gilbert White, *The Natural History of Selborne*, ed. Edward Jesse (London: George Pell and Sons, 1881), 122. The principal available scholarly edition, with a biography of White, selected letters and poems with notes, and a commentary on White's influence is *The Natural History of Selborne*, ed. E. M. Nicholson (New York: E. P. Dutton, n.d.). The "monographer" letter does not appear in this edition.

19. Nicholson, *Selborne*, 385.

20. Sir Davy Humphry, *Salmonia; or, Days of Fly Fishing, in a Series of Conversations, with Some Account of the Habits of Fishing Belonging to the Genus Salmo, by an Angler* (London: Murray, 1828)

21. Bence Jones, "The Life of Sir Humphry Davy," *The Royal Institution: Its Founder and Its First Professors* (London: Longmans, Green and Co., 1871), reprinted in *History, Philosophy, and Sociology of Science*, ed. Yehuda Elkana, et al. (New York: Arno Press, 1975), 336.

22. Edmund Gosse, *Life*, 257–58.

23. Philip Henry Gosse, *Evenings at the Microscope* (New York: P. F. Collier and Son, 1902), 4–5, 368.

24. For a review of pre–Civil War stresses in Alabama, see Leah Rawls Atkins, Wayne Flynt, William Warren Rogers, Robert David Ward, *Alabama: History of a Deep South State* (Tuscaloosa: University of Alabama Press, 1994), esp. 181. A brief but valuable appraisal emphasizing Gosse's picture of antebellum life is by Harvey H. Jackson III, "Introduction," *Letters from Alabama* by Philip Henry Gosse (Tuscaloosa: University of Alabama Press, 1993); see also, H. Jackson III, "Philip Henry Gosse: An Englishman in the Alabama Black Belt," *Alabama Heritage*, 1993 (Spring), 37–45.

25. Charles Dickens, *American Notes and Pictures from Italy* (Oxford University Press, 1957), 133–37. On his American tour, Dickens did not travel south of Richmond.

26. John James Audubon, "Passenger Pigeon," *Writings and Drawings*, ed. Christoph Irmscher (New York: Literary Classics of America, 1984), 264.

27. Audubon, Letter to John Bachman, Mobile, Feb. 24, 1837, *Selected Journals and Other Writings*, ed. Ben Forkner (New York: Penguin Books, 1997), 193–94.

28. Edmund Gosse, *Life*, 130.

29. See John Updike, "The Clarity of Things," *New York Review of Books*, vol. 55, no. 11 (June 26, 2008).

30. William Bartram, *Travels of William Bartram*, ed. Mark Van Doren (New York: Dover Publications, 1955), 15; Audubon, "The Raven," *Journals and Other Writings*, 566.

31. Edmund Gosse, *Life*, 130.

32. Charles William Day, *The Art of Miniature Painting: Comprising Instructions Necessary for the Acquirement of That Art* (London: Winsor and Newton, 1852), 12, 15–18, 19–21. All the materials Gosse might have needed were available at Winsor and Newton (London) and other "artists' colour shops" in the early nineteenth century: black-lead pencils, crayons (black, white, and red chalk), crow-quill pens, Indian ink, camel's hair and sable pencils (brushes), scrapers, glass palettes, drawing paper, gum arabic, ox gall, painting boxes, and a wide choice of watercolors. The likelihood is that Gosse used #000 sable brushes for his stippling, similar to Winsor & Newton's Series 7 Kolinsky miniature brushes, which are still sold today.

33. Henry Harrison, *Instructions for the Mixture of Watercolours: Adapted to the Various Styles of Miniature Painting, and Also to Landscape, Flower, and Fruit Painting*, 3rd ed. (London: J. Souter, School-Library, 1833), 3–7. Includes a list of the following fifty-eight commercially available watercolors, with the number of different kinds for each: blues—eight, reds—sixteen, yellows—twelve, browns—eleven, blacks—three, whites—three, grays—two, and purples—three.

34. Charles William Day, *The Art of Miniature Painting*, 52.

35. Edmund Gosse, *Life*, 341.

36. Ibid.

THE PLATES

PL 1. **Pipevine swallowtail,** *Battus philenor* (Linnaeus), female (top) and **Black swallowtail,** *Papilio polyxenes* (Fabricius), female (bottom); on **Trumpet creeper,** *Campsis radicans* (Linnaeus).

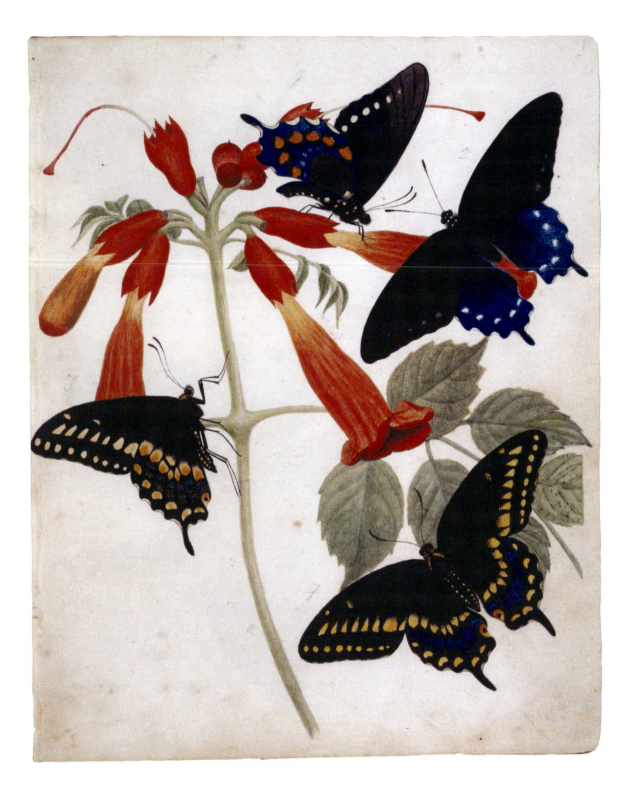

PL 2. **Eastern tiger swallowtail,** *Papilio glaucus* (Linnaeus), female, black form; on **Day-flower,** *Commelina erecta* (Linnaeus).

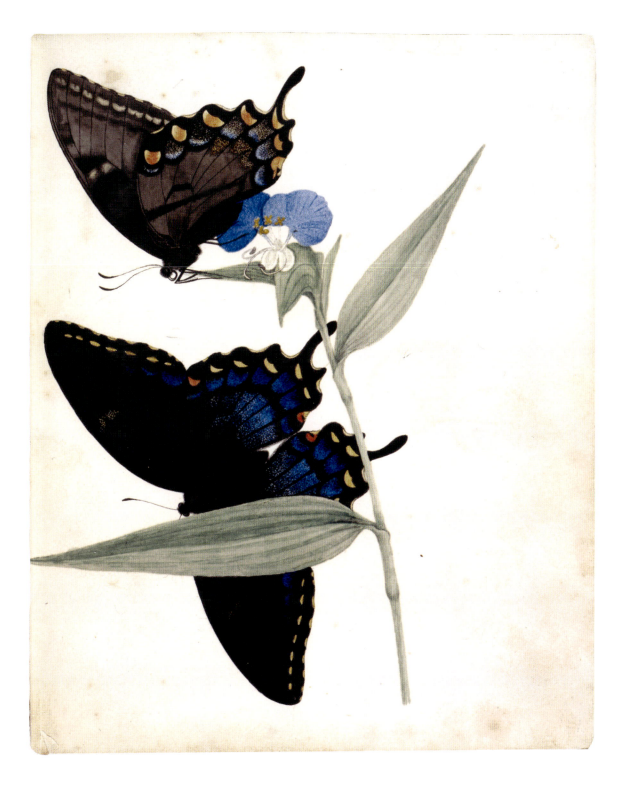

PL 3. **Palamedes swallowtail,** *Papilio palamedes* (Drury) (top) and **Tiger swallowtail,** *Papilio glaucus* (Drury) (bottom); on **Bermuda grass,** *Cynodon dactylon* (Linnaeus).

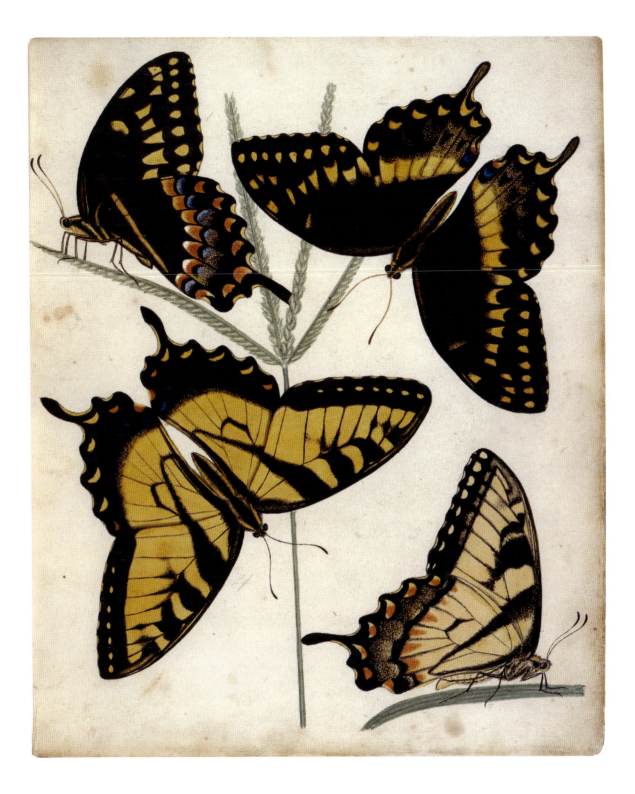

PL 4. **Zebra swallowtail,** *Eurytides marcellus* (Cramer) (left) and **Spicebush swallowtail,** *Papilio troilus* (Linnaeus) (right), on **Purple cone-flower,** *Echinaceae purpurea* (Linnaeus).

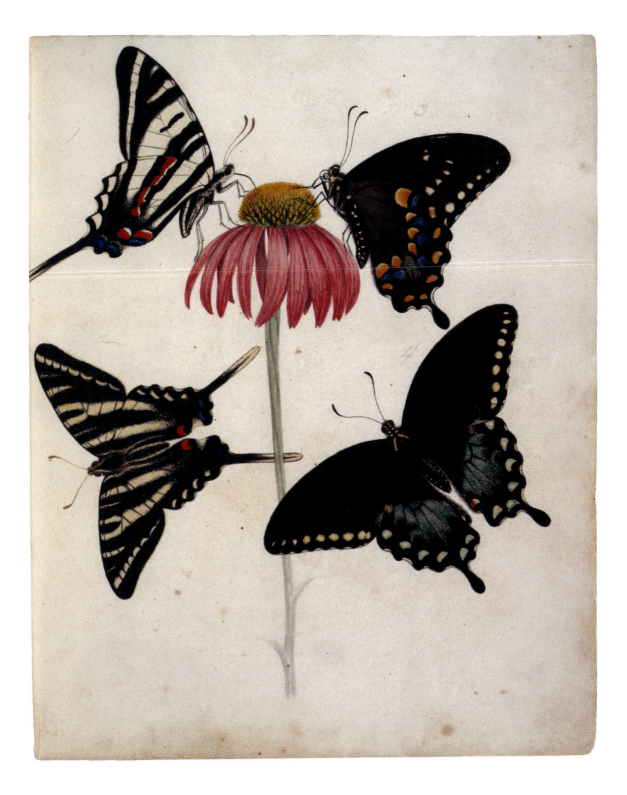

PL 5. **Giant swallowtail,** *Papilio cresphontes* (Cramer).

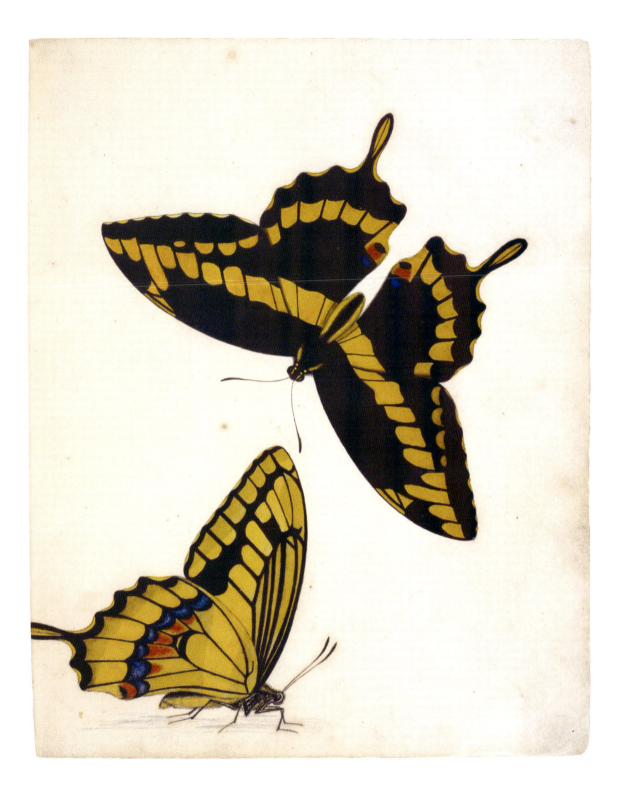

PL 6. **Monarch,** *Danaus plexippus* (Linnaeus); on **Indian pink,** *Spigelia marilandia* (Linnaeus).

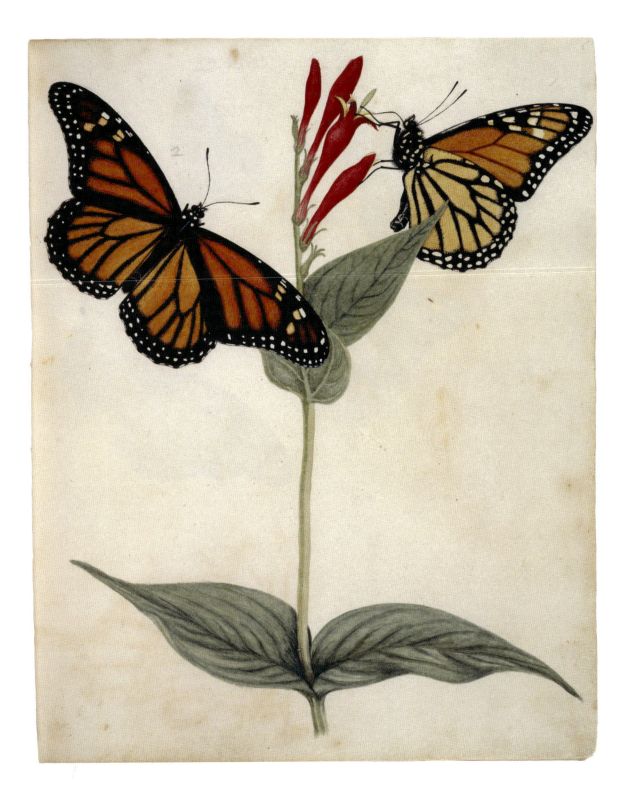

PL 7. **Variegated fritillary,** *Euptoieta claudia* (Cramer) (left); **Gulf fritillary,** *Agraulis vanillae* (Linnaeus) (right).

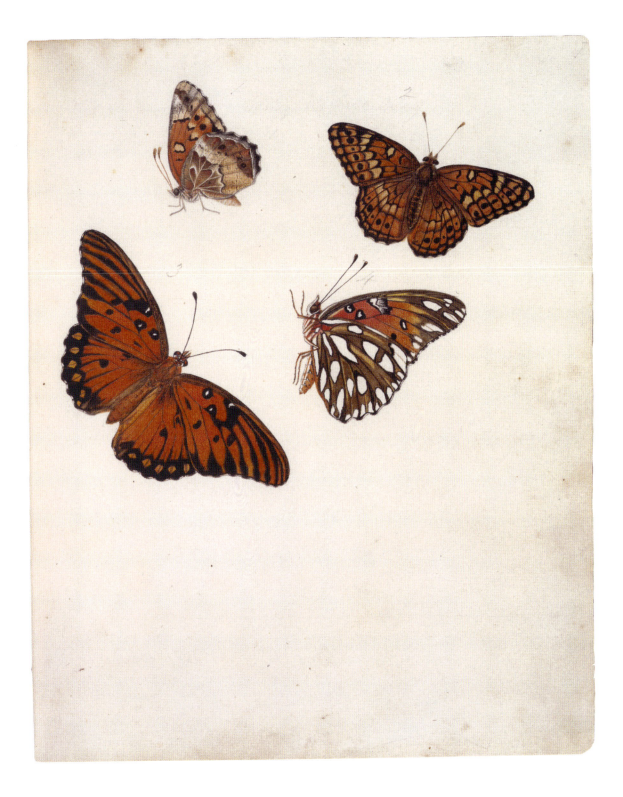

PL 8. **Pearl crescent,** *Phyciodes tharos* (Drury); on **False foxglove,** *Aurelia flava* (Linnaeus).

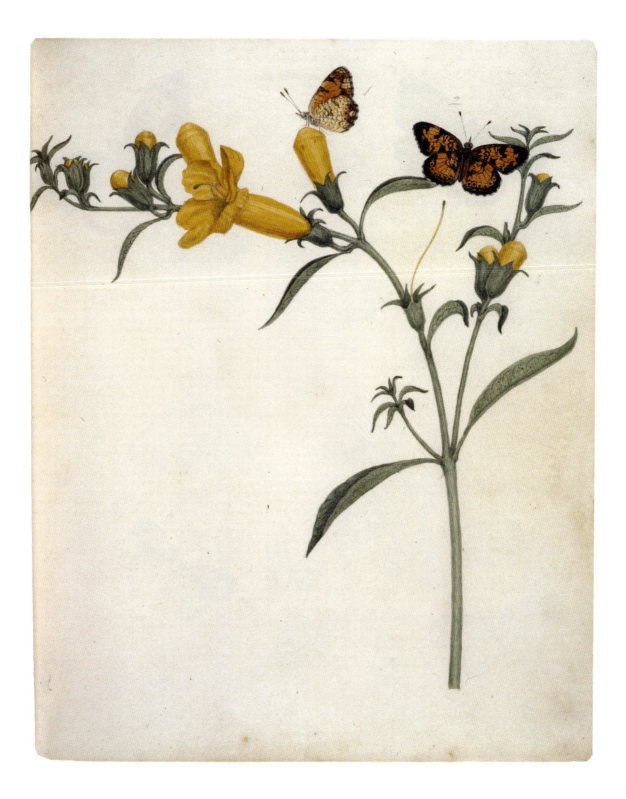

PL 9. Sulphurs and Yellows: **Dogface,** *Zerene cesonia* (Stoll) (top, left); **Sleepy orange,** *Eurema nicippe* (Cramer) (top, right); **Cloudless sulphur,** *Phoebis sennae* (Linnaeus) (middle and middle, right); **Barred yellow,** *Eurema daira* (Godart) (bottom, left); **Little yellow,** *Eurema lisa* (Boisduval and LeConte) (bottom, middle and right).

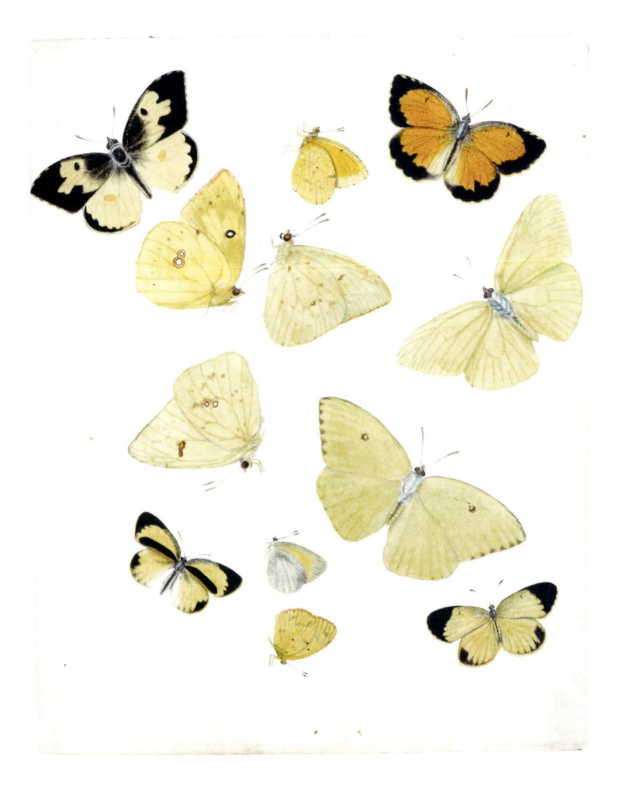

PL 10. **Eastern comma,** *Polygonia comma* (T. Harris) (left); **Question mark,** *Polygonia interrogationis* (Fabricius) (right); on **Many-flowered zinnia,** *Zinnia multiflora* (Linnaeus).

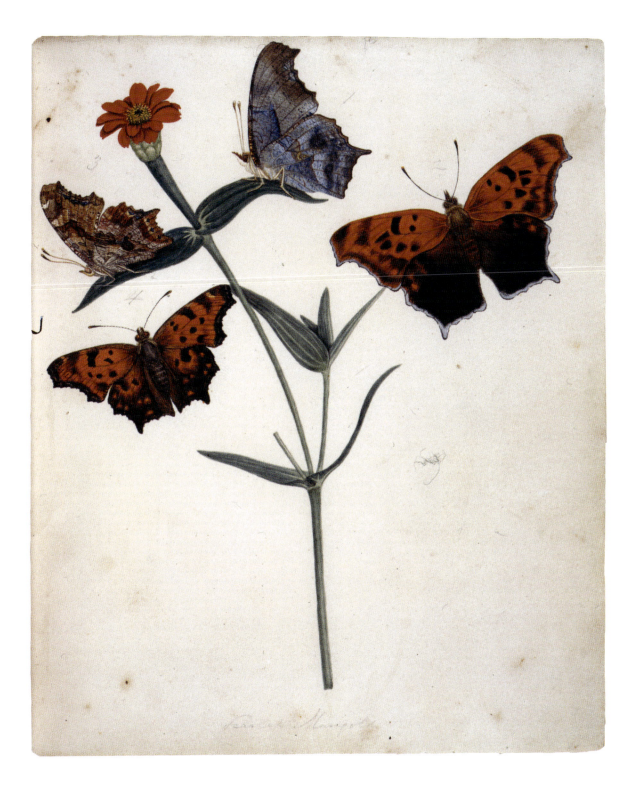

PL II. **Common buckeye,** *Junonia coenia* (Hübner) (left) and **Red admiral,** *Vanessa atalanta* (Linnaeus) (right); on **Butterfly pea,** *Centrosema virginianum* (Linnaeus).

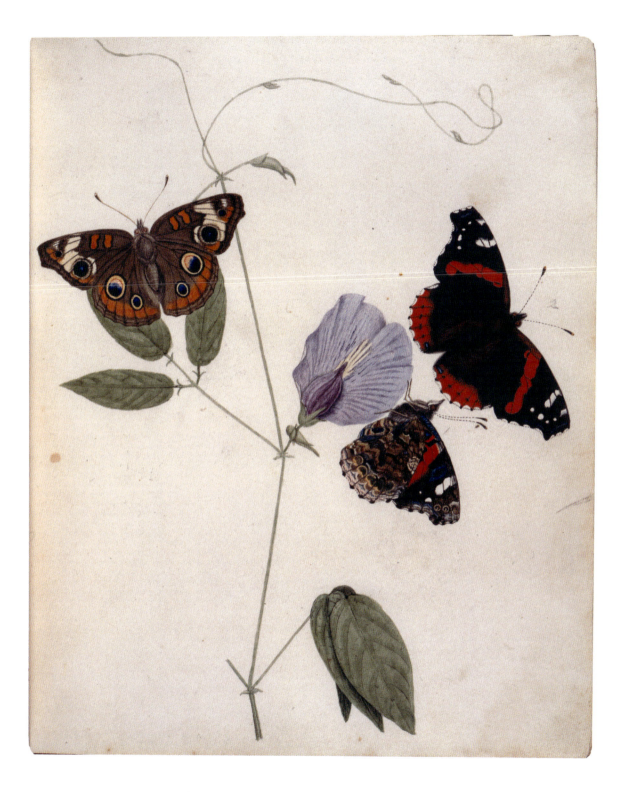

PL 12. **American lady,** *Vanessa virginiensis* (Drury); on **Evening primrose,** *Oenothera grandiflora* (Linnaeus).

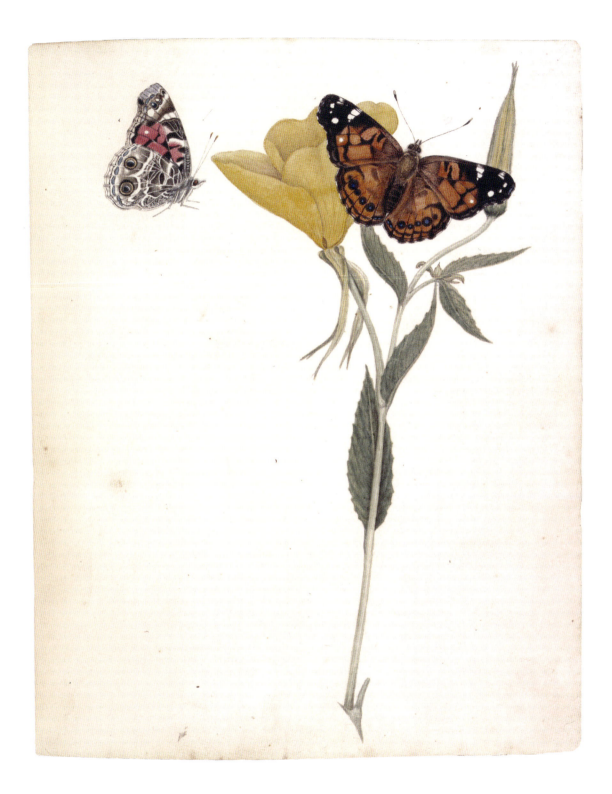

PL 13. **Red-spotted purple,** *Limnetis arthemis astyanax* (Fabricius); on **Indian-shot,** *Canna indica* (Linnaeus).

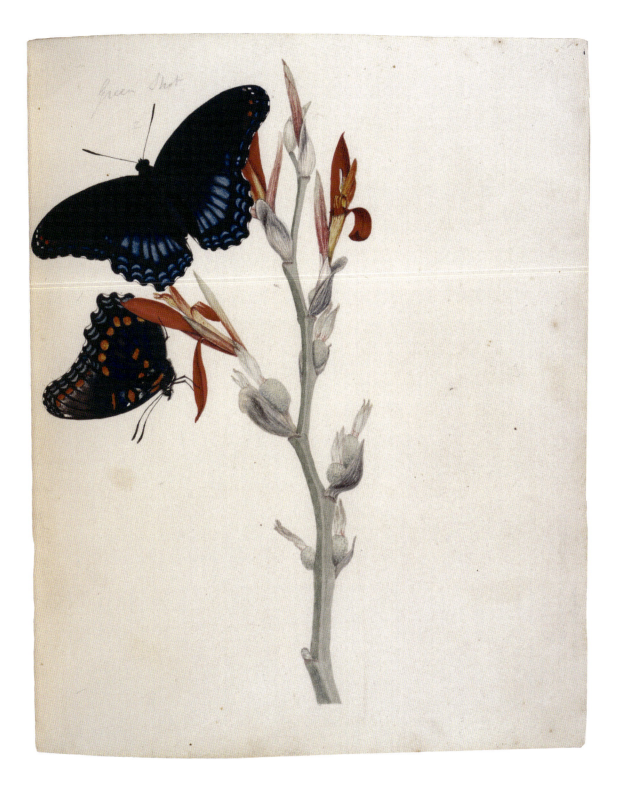

Green Shot

PL 14. **Southern pearly eye,** *Enodia portlandia* (Fabricius) (top two) and two forms of **Common wood nymph,** *Cercyonis pegala* (Fabricius) (bottom four); on **Coral bean,** *Erythrina herbacea* (Linnaeus).

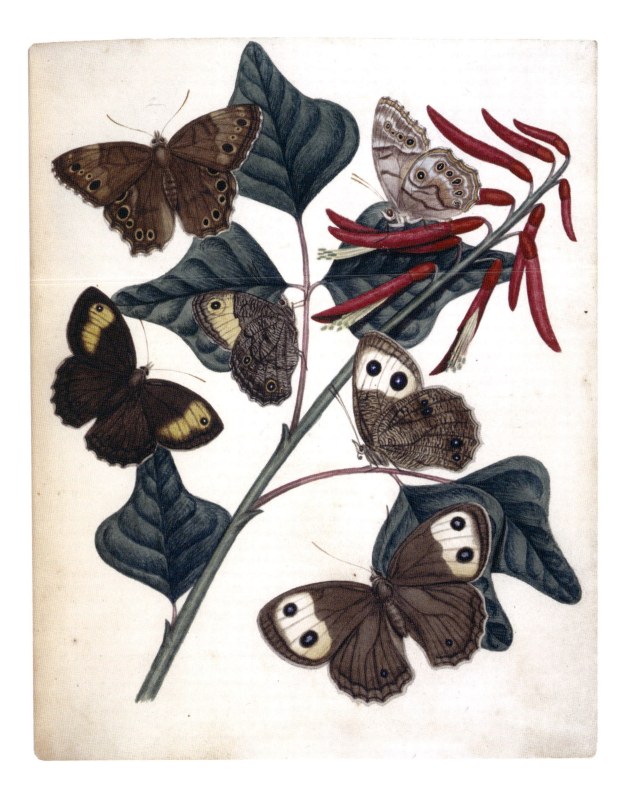

PL 15. Satyrs: **Gemmed satyr,** *Cyllopsis gemma* (Hübner) (top, left two); **Georgia satyr,** *Neonympha areolata* (J. E. Smith) (top, right two); **Little wood satyr,** *Megisto cymelea* (Cramer) (bottom, left two); **Carolina satyr,** *Hermeuptychia sosybius* (Fabricius) (bottom, right two).

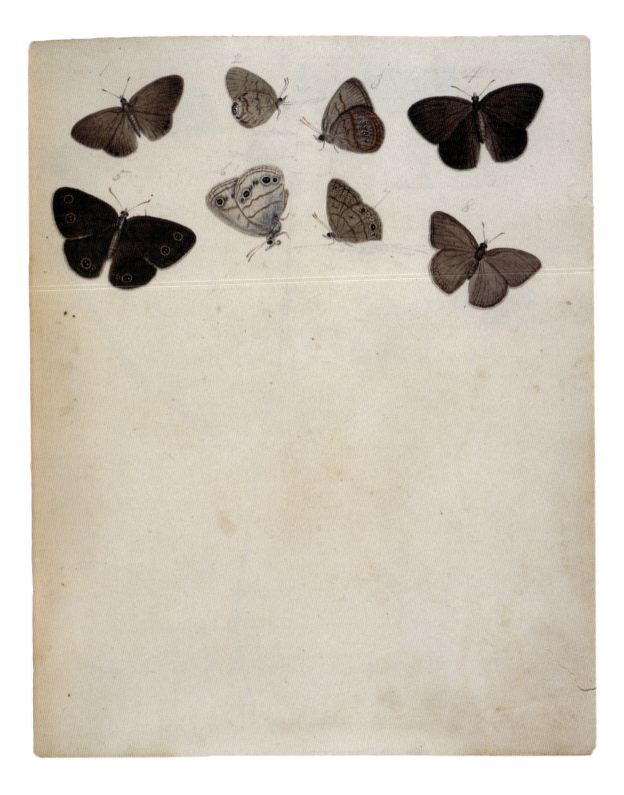

PL 16. Hairstreaks, blues, and azures on **Yellow Indiangrass,** *Sorghastrum nutans* (Linnaeus): **Banded hairstreak,** *Satyrium calanus* (Hübner) (top, left); **Eastern tailed blue,** *Everes comyntas* (Godart) (top, middle); **Spring azure,** *Celastrina argiolus* (Cramer) (top, right); **Red-banded hairstreak,** *Calycopis cecrops* (Fabricius) (middle, right); and **Southern hairstreak,** *Satyrium favonius favonius* (J. E. Smith) (bottom, right).

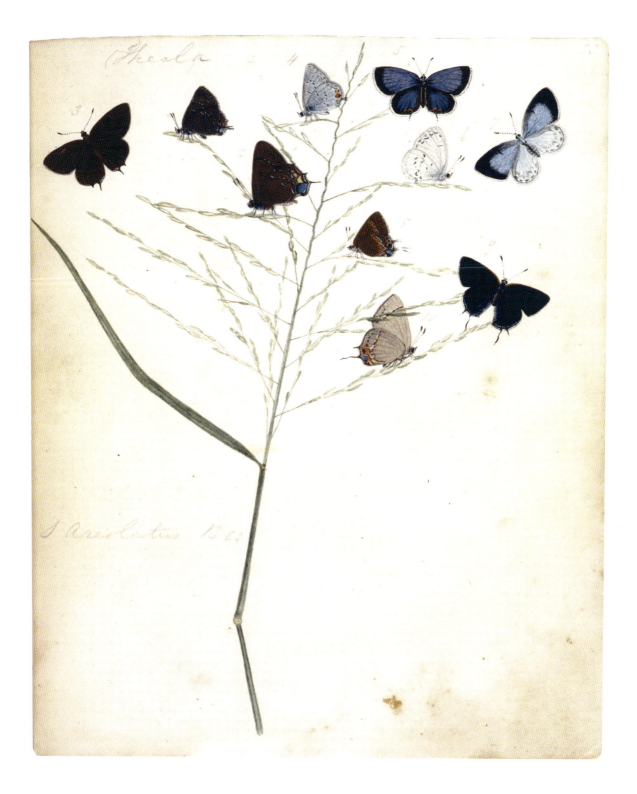

Thecla 4 5

3 6

S. areolatus B 68

PL 17. **Coral hairstreak,** *Satyrium titus* (Fabricius).

1 ♂ Thecla Falacer (Bois 24)
3 ♂ Cat. oval - blkspot - Chry. ?

Bois 36 — Cat. pale with diag. bro. streaks - Chry. brown

Bois 36 — see below ♂

Bois 35 — Husticus armatus Poeas Hut

my live butterup in Rosa the freaders

Thecla Hyperici (Bois 28)

PL 18. Skippers, seven species on **Pencilflower,** *Stylosanthes biflora* (Linnaeus): **Silver-spotted skipper,** *Epargyreus clarus* (Cramer) (first row, left and right); **Hoary edge skipper,** *Achalarus lyciades* (Geyer) (second row, left; third row, left); **Horace's duskywing,** *Erynnis horatius* (Scudder and Burgess) (second row, middle and right); **Common checkered-skipper,** *Pyrgus communis* (Grote) (fourth row, left and middle); **Fiery skipper,** *Hylephila phyleus* (Drury), male (third row, left and middle); **Southern cloudywing,** *Thorybes bathyllus* (J. E. Smith) (fourth row, right; fifth row, right) and **Common sootywing,** *Pholisora catullus* (Fabricius) (fifth row, left and middle).

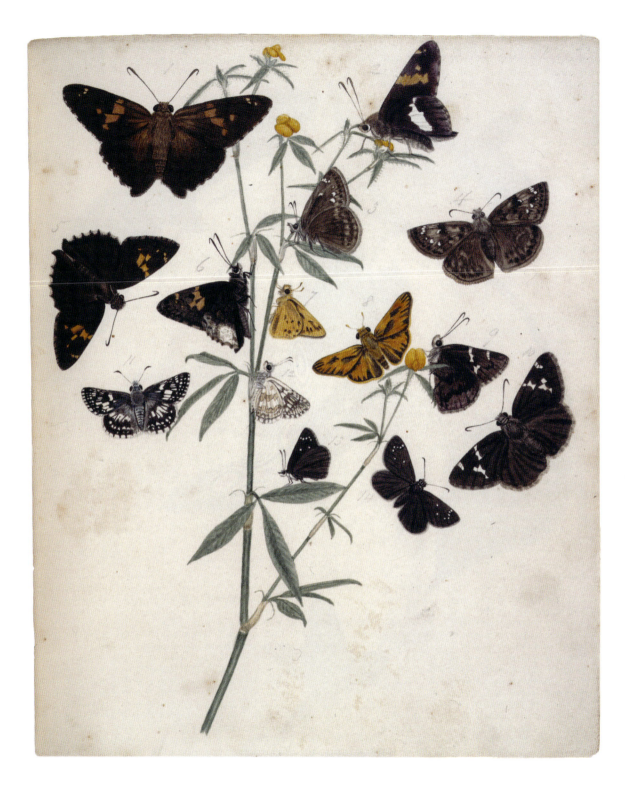

PL 19. Hawk moths: **Tobacco hornworm,** or **Carolina sphinx,** *Manduca sexta* (Linnaeus) (top, left); **Hog sphinx,** or **Virginia creeper sphinx,** *Darapsa myron* (Cramer) (top, right); **White-lined sphinx,** *Hyles lineata* (Fabricius) (middle); **Tersa sphinx,** *Xylophanes tersa* (Linnaeus) (bottom); on **Red morning-glory,** *Ipomoea coccinea* (Linnaeus).

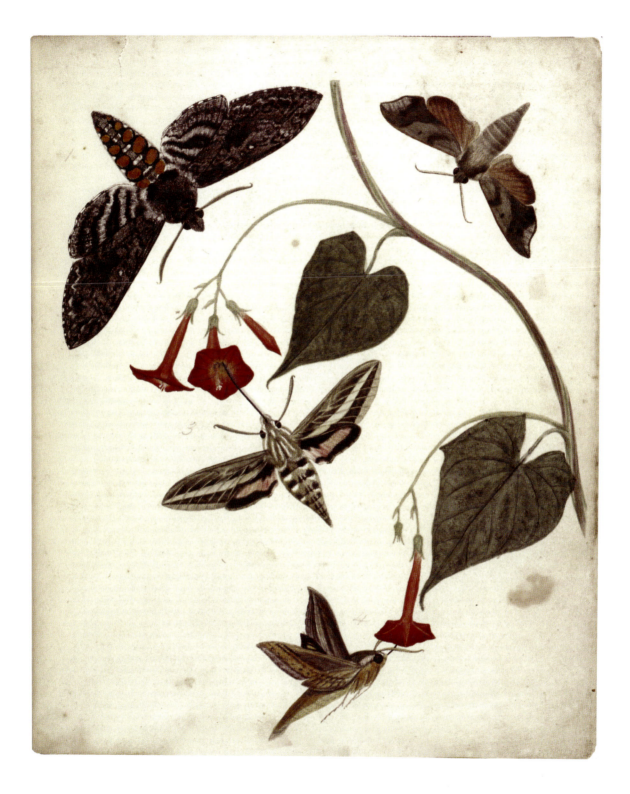

PL 20. Hawk moths: **Banded sphinx,** *Eumorpha fasciata* (Sulzer) (top, left); **Hummingbird clearwing,** *Hemaris thysbe* (Fabricius) (top, right); **Hermit sphinx,** *Linterneria eremitus* (Hübner) (middle, left), and **Pandorus sphinx,** *Eumorpha pandorus* (Hübner) (bottom, right); on **Cypress vine,** *Ipomoea quamoclit* (Linnaeus).

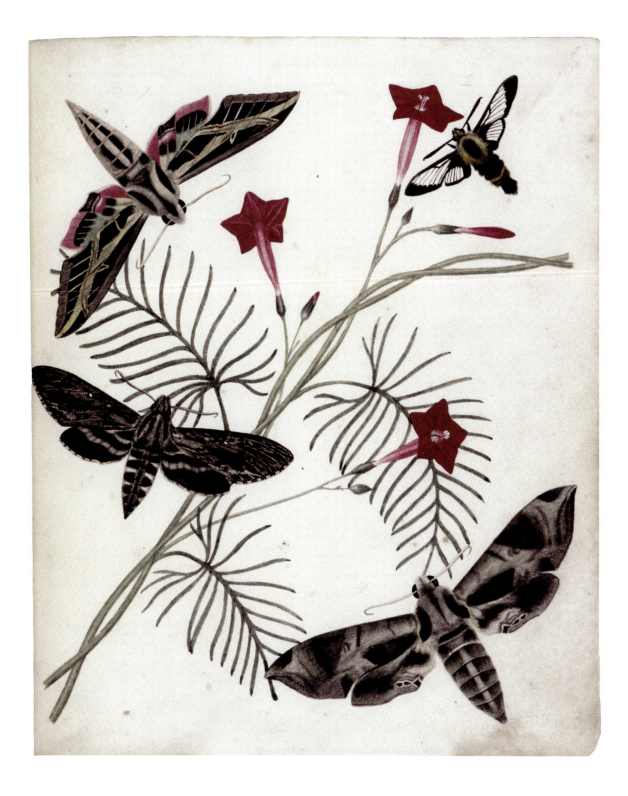

PL 21. Hawk moths: **Pink-spotted hawk moth,** *Agrius cingulatus* (Fabricius) (top, left);
Blinded sphinx, *Paonias excaecatus* (J. E. Smith) (bottom, right).

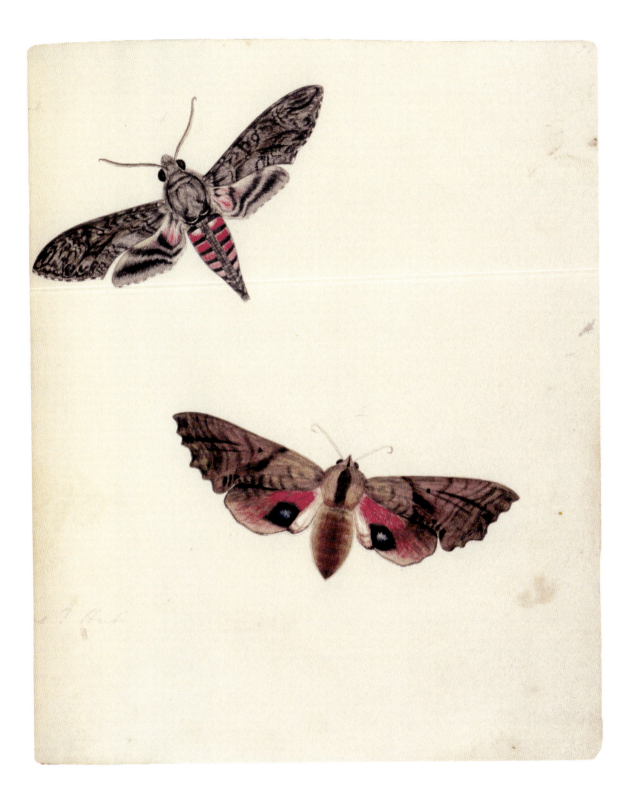

PL 22. Giant silkworm moths: **Imperial moth,** *Eacles imperialis* (Drury) (top);
Io moth, *Automeris io* (Fabricius) (bottom).

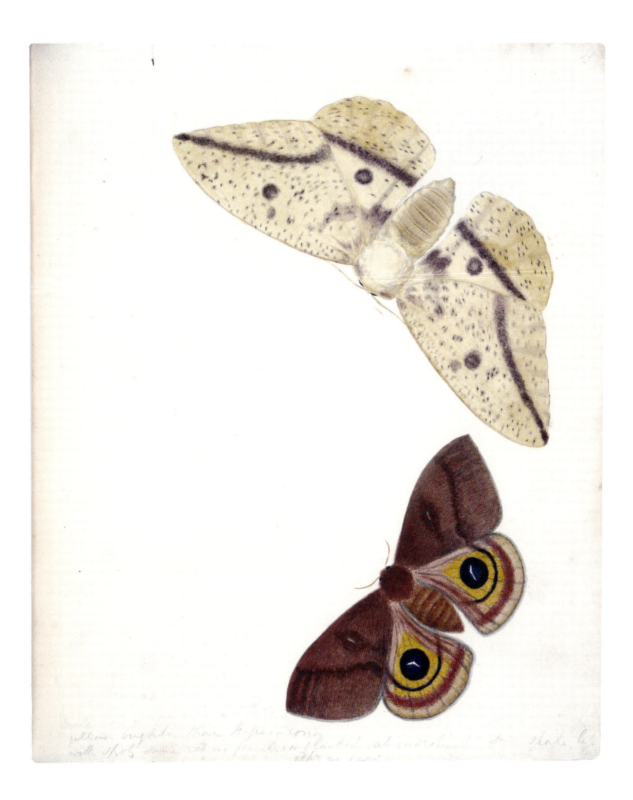

PL 23. **Polyphemus moth,** *Antheraea polyphemus* (Cramer), male.

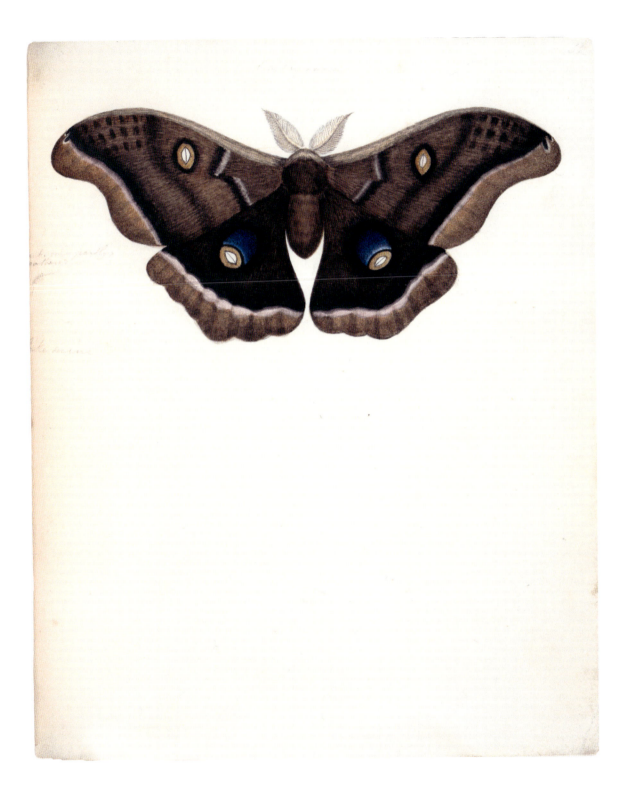

PL 24. **Luna moth,** *Actias luna* (Linnaeus), male.

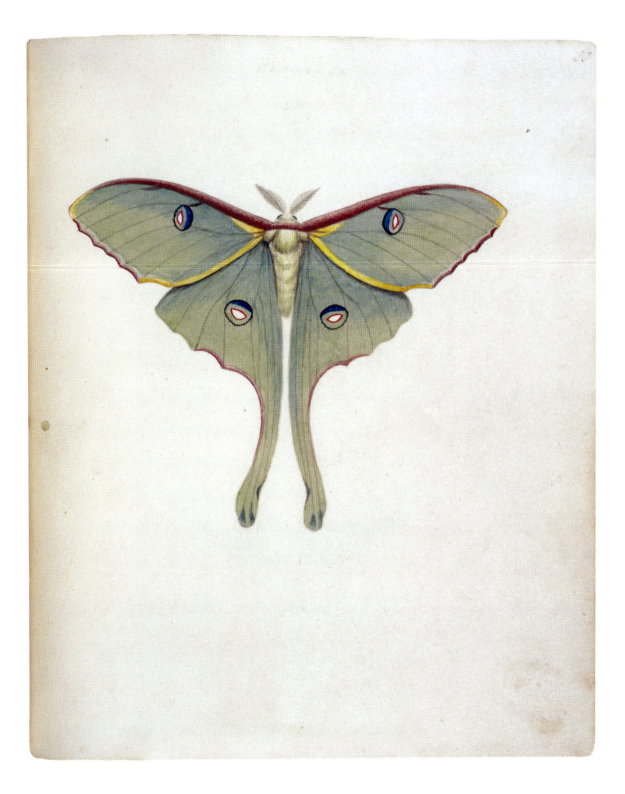

PL 25. Moths: **Large tolype,** *Tolype velleda* (Stoll) (top); **Spiny oakworm moth,** *Anisota stigma* (Fabricius) (bottom).

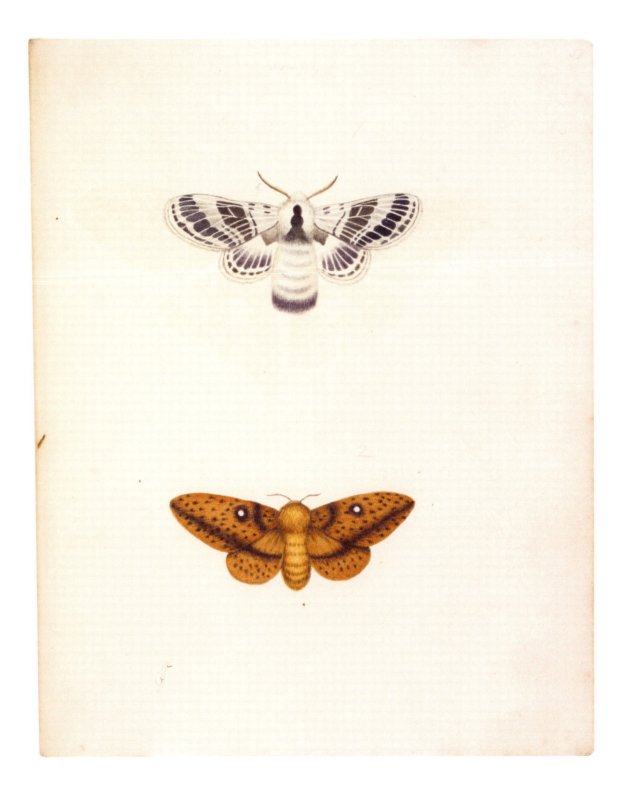

PL 26. **Giant leopard moth,** *Hypercompe scribonia* (Stoll).

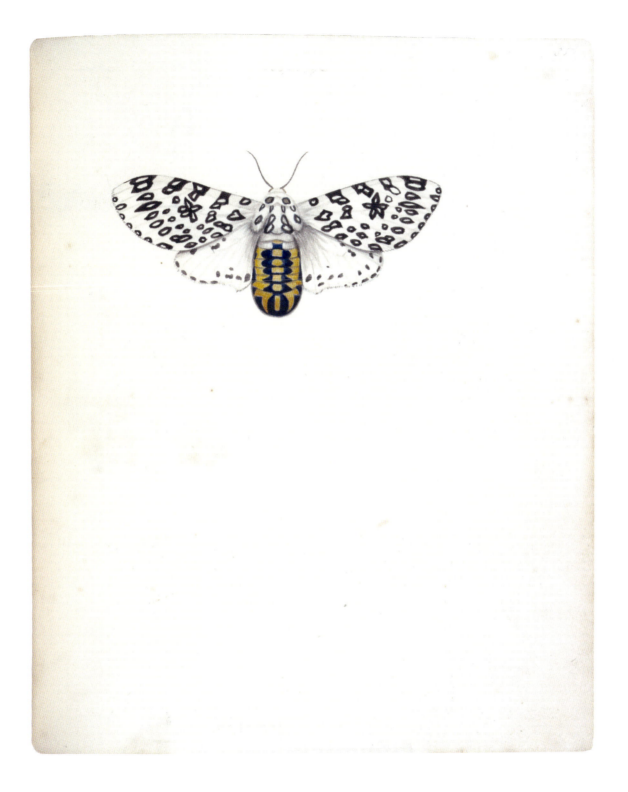

PL 27. Arctiid moths and other species: **Colona moth,** *Haploa colona* (Hübner), form *fulvicosta* (first row, far left); **Reversed haploa moth,** *Haploa reversa* (Stretch) (first row, second from left); **Salt marsh moth,** *Estigmene acrea* (Drury) (first row, third from left); **Orange-patched smoky wing,** *Pyromorpha dimidiata* (Hërrich-Schaffer) (second row, far left); **Placentia tiger moth,** *Grammia placentia* (J. E. Smith) (second row, second from left); **Oblique heterocampa,** *Heterocampa oblique* (Packard), adult moth resting on plant stem (second row, right); **Orange holomelina,** *Holomelina aurantiaca* (Hübner) (third row, far left); **Evergreen bagworm moth,** *Thyridopteryx ephemeraeformis* (Haworth) (third row, second from left); **Eastern tent caterpillar moth,** *Malacosoma americanum* (Fabricius), adult male (third row, far right); **Virgin tiger moth,** *Grammia virgo* (Linnaeus) (fourth row).

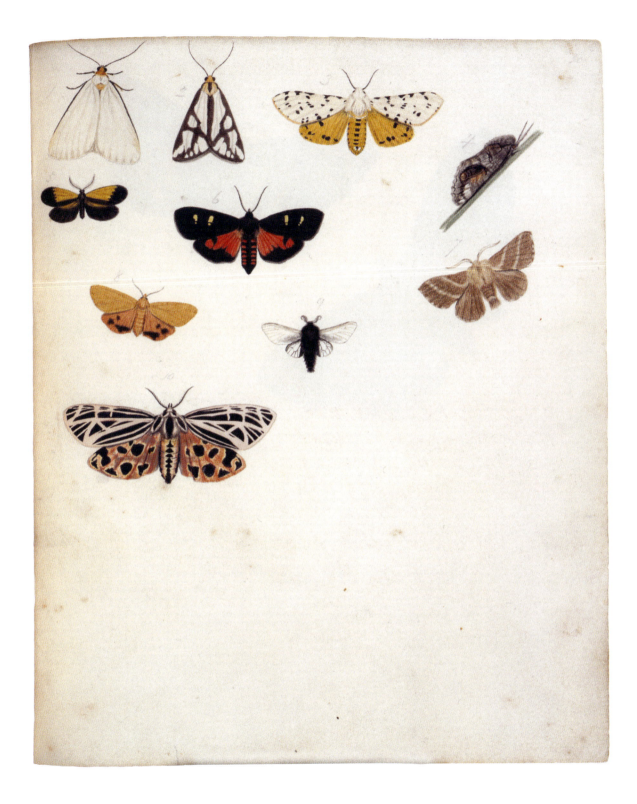

PL 28. Underwing moths: **Ilia underwing,** *Catocala ilia* (Cramer) (left), **Darling underwing,** *Catocala cara carissima* (Hulst) (right).

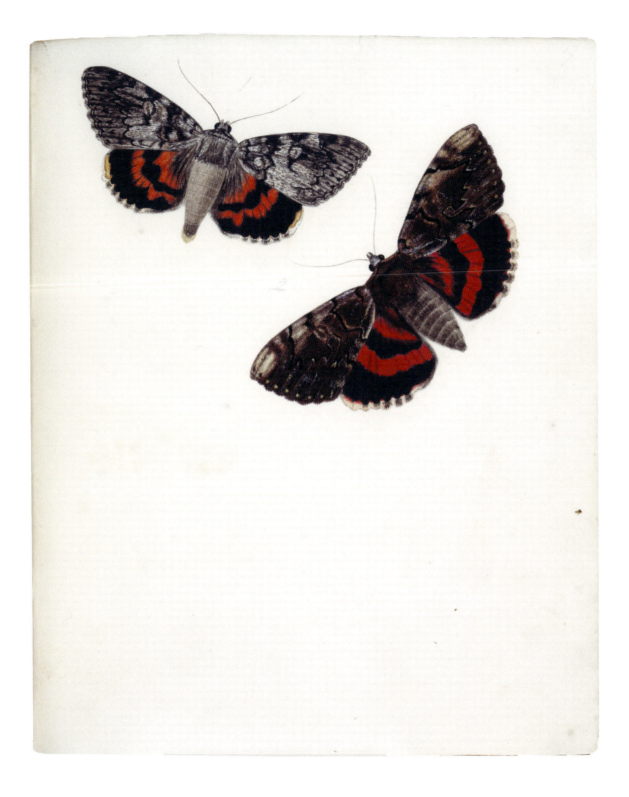

PL 29. **Red-bordered emerald,** *Nemoria lixaria* (Guenée) or **Ferguson's emerald,** *Nemoria saturiba* (Ferguson) (top, left); **Zebra conchylodes,** *Conchylodes ovulalis* (Guenée) (top, right); **Large maple spanworm moth,** *Prochoerodes lineola* (Drury) (bottom, left); and **Southern purple mint moth,** *Pyrausta laticlavia* (Grote and Robinson) (bottom, right).

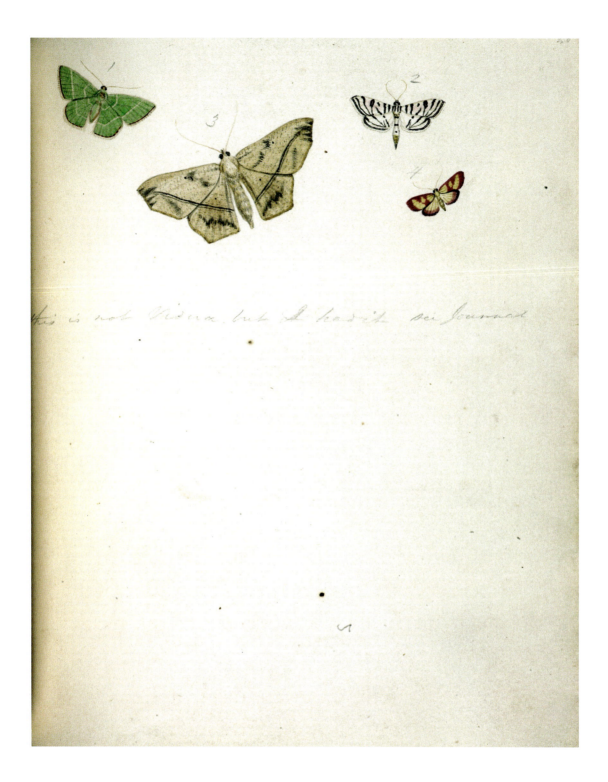

this is not Visua, but I had it see Journal

PL 30. **Epione underwing,** *Catocala epione* (Drury) (top); **Bella moth,** *Utetheisa bella* (Linnaeus) (bottom).

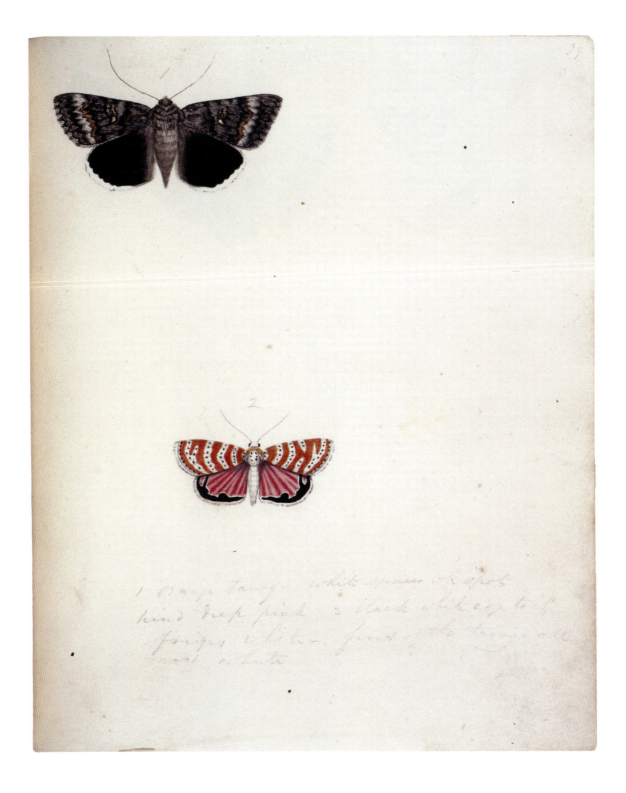

PL 31. Dragonflies: Gomphidae female (top, left); **Common sanddragon,** *Progomphus obscurus* (Rambur), male (bottom, right); note the complex pattern of wing veins.

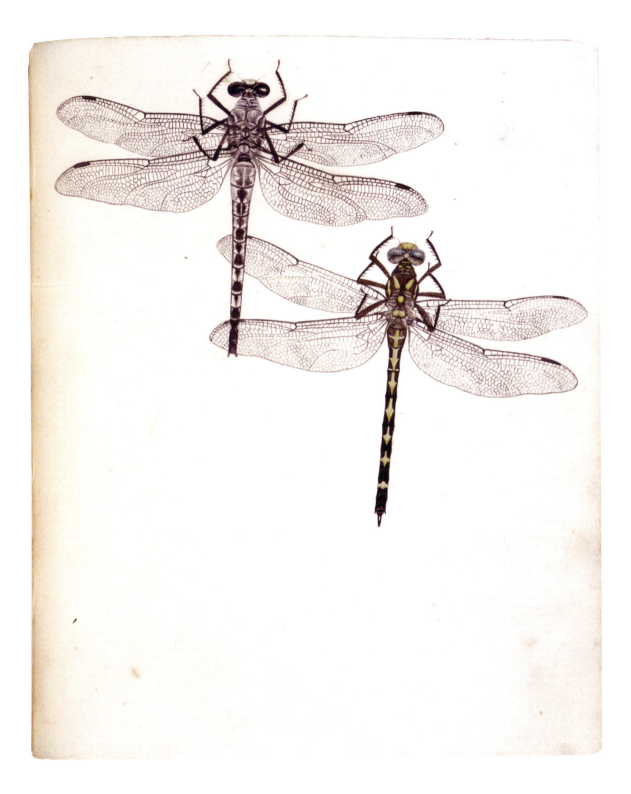

PL 32. Dragonflies: **Common whitetail,** *Plathemis lydia* (Drury), female (top, left); **Painted skimmer,** *Libellula semifasciata* (Burmeister), male (top, right); and **Blue corporal,** *Ladona deplanta* (Rambur), female (bottom).

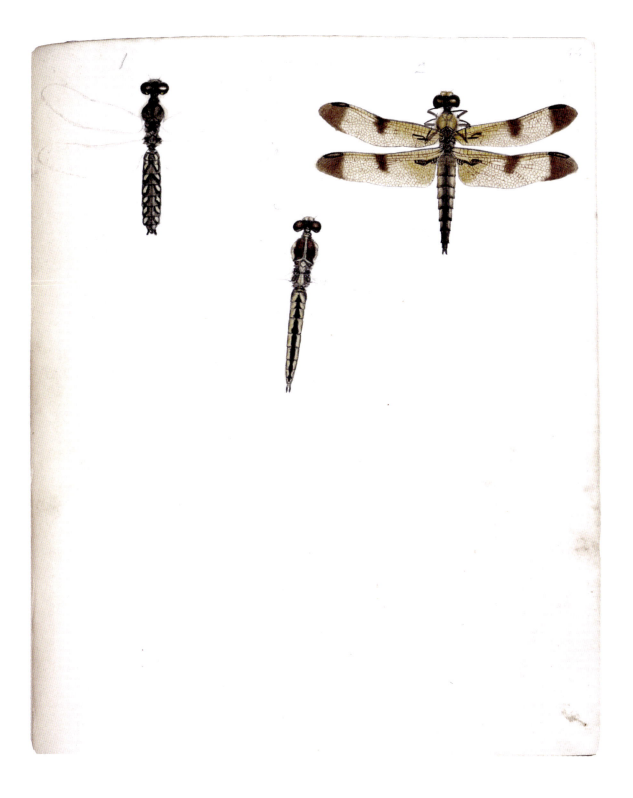

PL 33. Broad-winged damselfly: **Ebony jewelwing,** *Calopteryx maculata* (Beauvois), male.

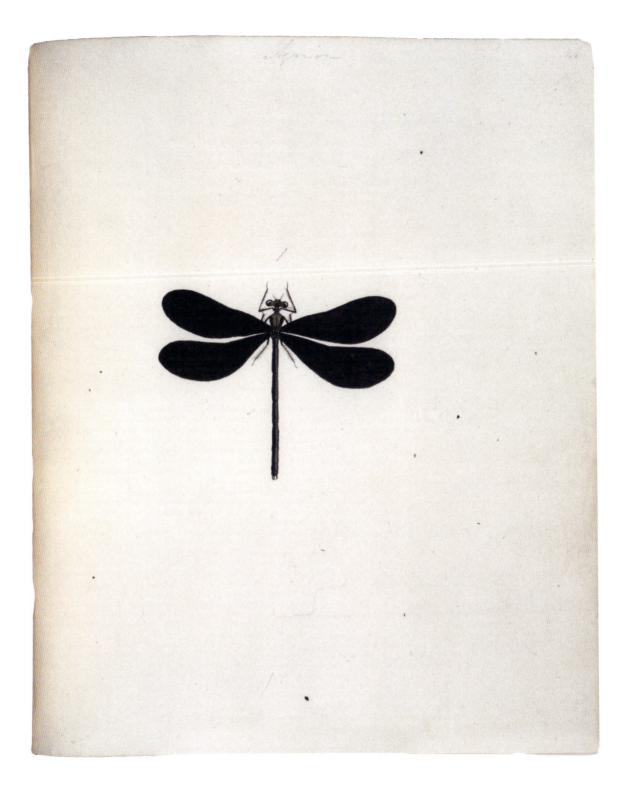

PL 34. Caterpillars, pupae, and chrysalides: **Hoary edge,** *Achalarus lyciades* (Geyer), skipper (first row, left); **Monarch,** *Danaus plexippus* (Linnaeus) (first row, right); **Variegated fritillary,** *Euptoieta claudia* (Cramer) (second row, left); **Pipevine swallowtail,** *Battus philenor* (Linnaeus) (second row, middle); **Zebra swallowtail,** *Eurytides marcellus* (Cramer) (second row, right); **Meadow fritillary,** *Boloria bellona* (Fabricius) ? (third row, left); and two **Saddleback** caterpillars, *Acharia stimulea* (Clemens), dorsal and lateral views (third row, right).

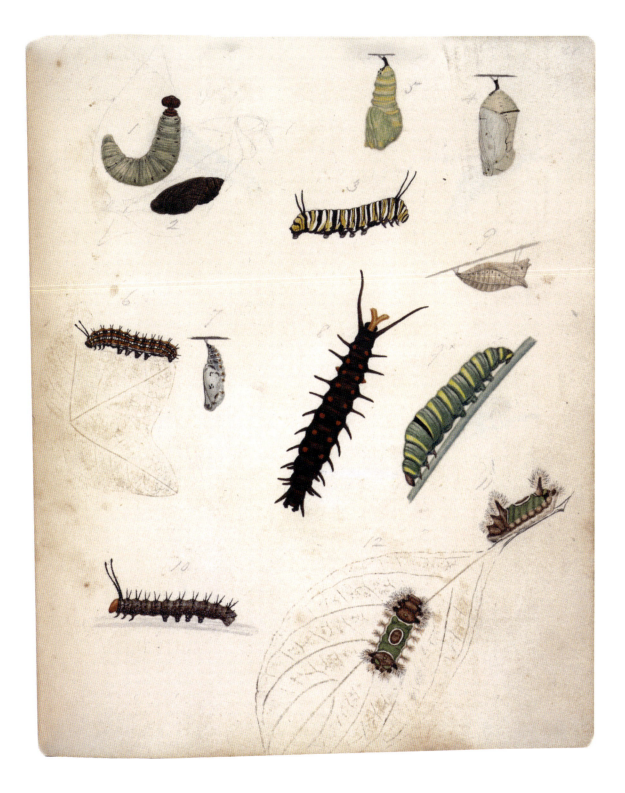

PL 35. **Spicebush swallowtail,** *Papilio troilus* (Linnaeus), caterpillar on sassafras leaf (top, left) and chrysalis (top, right); **Horace's duskywing,** skipper caterpillar, *Erynnis horatius* (Scudder and Burgess), on oak leaf (bottom, left); and **Giant swallowtail** caterpillar, *Papilio cresphontes* (Cramer) (bottom, right).

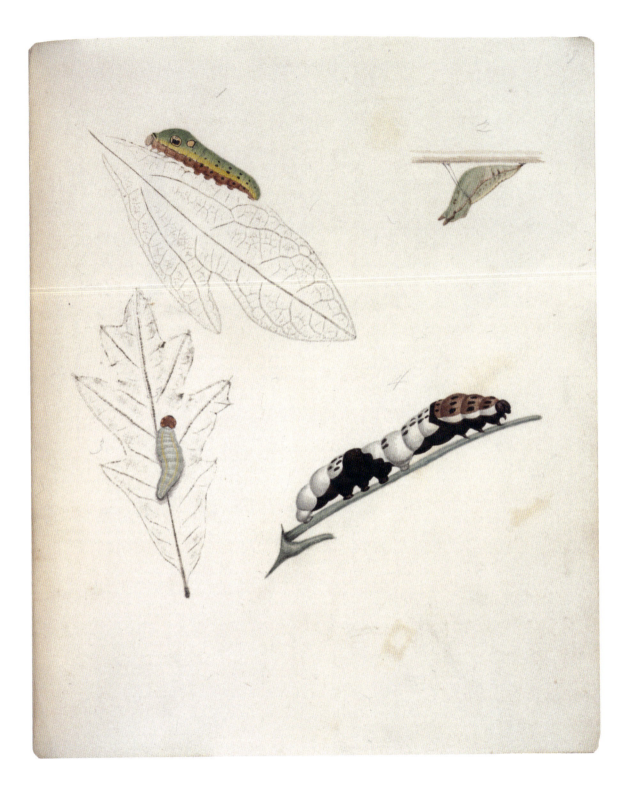

PL 36. **American lady,** *Vanessa virginiensis* (Drury), caterpillar.

PL 37. Hawk-moth caterpillars and pupae: **Tobacco hornworm,** or **Carolina sphinx,** *Manduca sexta* (Linnaeus) (top, left); **Southern pine sphinx,** *Lapara coniferarum* (J. E. Smith) (top, right); **Pink-spotted hawk moth,** *Agrius cingulatus* (Fabricius) (bottom, left); and **Banded sphinx,** *Eumorpha fasciata* (Sulzer) (bottom, right).

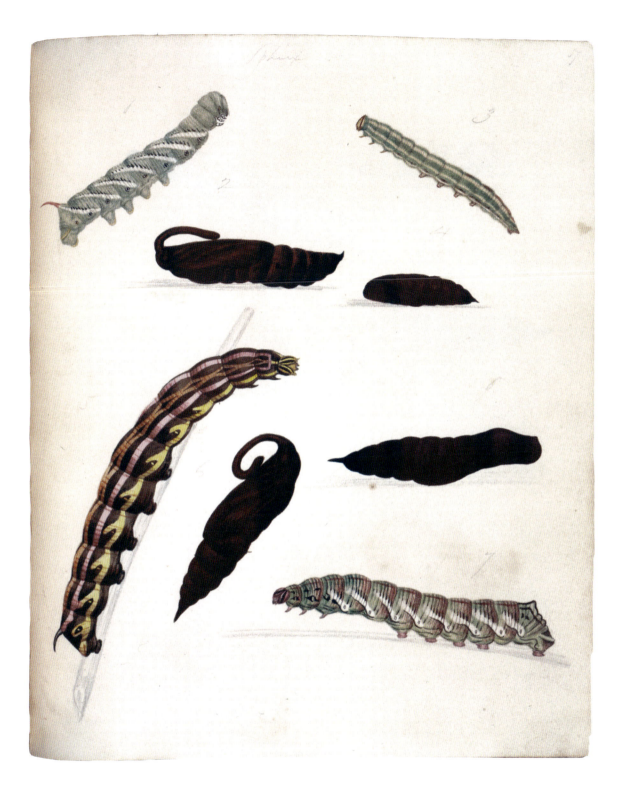

PL 38. Two hawk moths, caterpillars and pupae: **Tersa sphinx,** *Xylophanes tersa* (Linnaeus) (top); **White-lined sphinx,** *Hyles lineata* (Fabricius) (bottom).

2

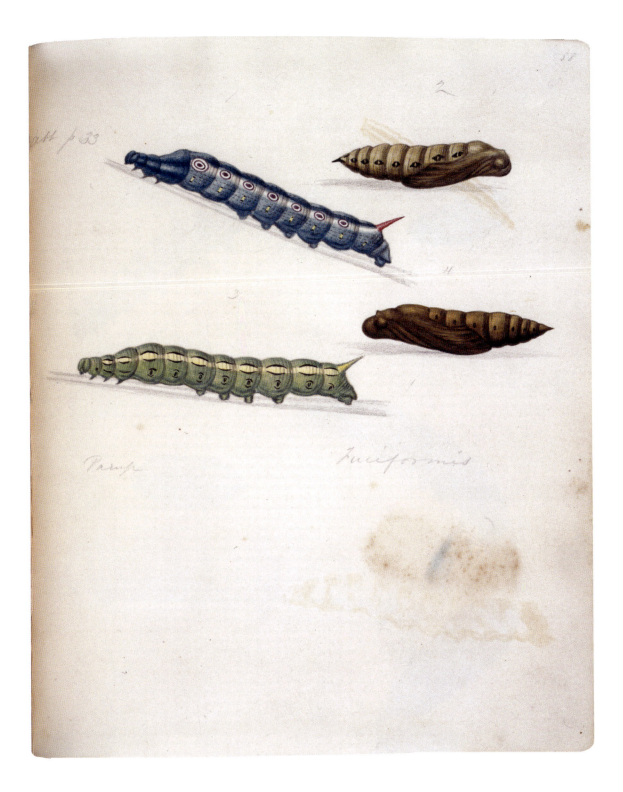

Pup.

fuciformis

PL 39. Moth caterpillars and pupae: **Io moth,** *Automeris io* (Fabricius) (top); **Luna moth,** *Actias luna* (Linnaeus) (middle); and **Imperial moth,** *Eacles imperialis* (Drury) (bottom).

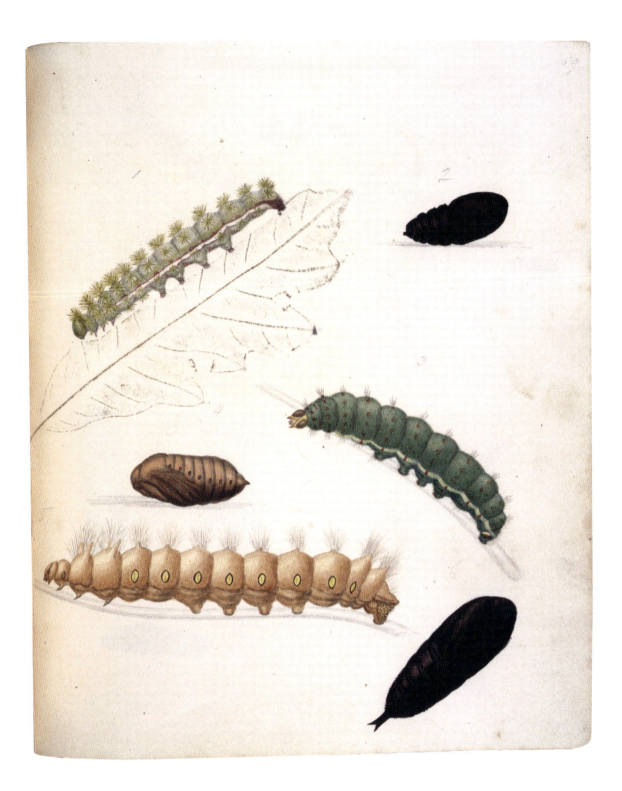

PL 40. Caterpillars, pupae and cocoons: **Spiny oakworm,** *Anisota stigma* (Fabricius) on oak, with pupa (top, left); **Evergreen bagworm moth,** *Thyridopteryx ephemeraeformis* (Haworth), silken case and caterpillar (middle, right); unidentified species (bottom, left); and **Major datana,** *Datana major* (Grote and Robinson) (bottom, right).

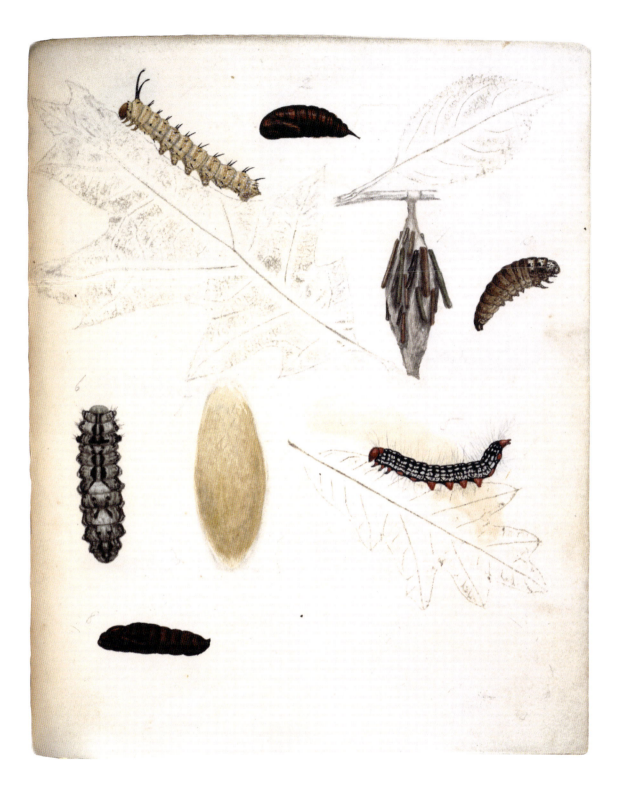

PL 41. Caterpillars and pupae of moths: **Dubious tiger moth,** *Spilosoma dubia* (Walker) (first row, left); **Yellow-haired dagger moth,** *Acronicta impleta* (Walker) (first row, middle); **White-dotted prominent,** *Nadata gibbosa* (J. E. Smith) (first row, right); **Saltmarsh caterpillar,** *Estigmene acrea* (Drury) (second row, left); **Carpenterworm moth,** *Prionoxystus robiniae* (Peck), with pupa (second row, right); Gelechiidae, unidentified, with pupa (third row, left); **Pink-striped oakworm,** *Anisota virginiensis* (Drury) (fourth row, left); **The Confederate,** *Condica vecors* (Guenée) or *C. confederata* (Grote) (fourth row, right).

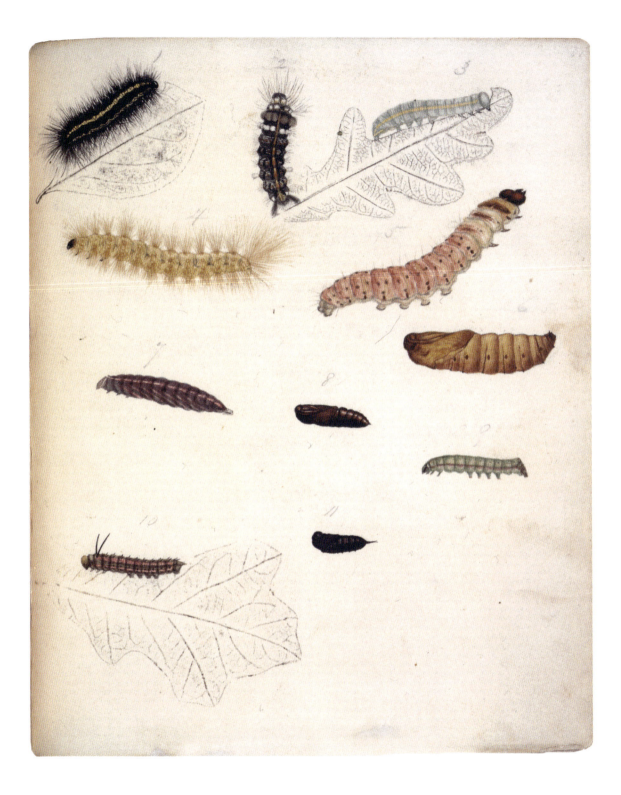

PL 42. **Mole cricket,** *Neocurtilla hexadactyla* (Perty) (top); **Eastern lubber grasshopper,** *Romalea microptera* (Beauvois) (bottom).

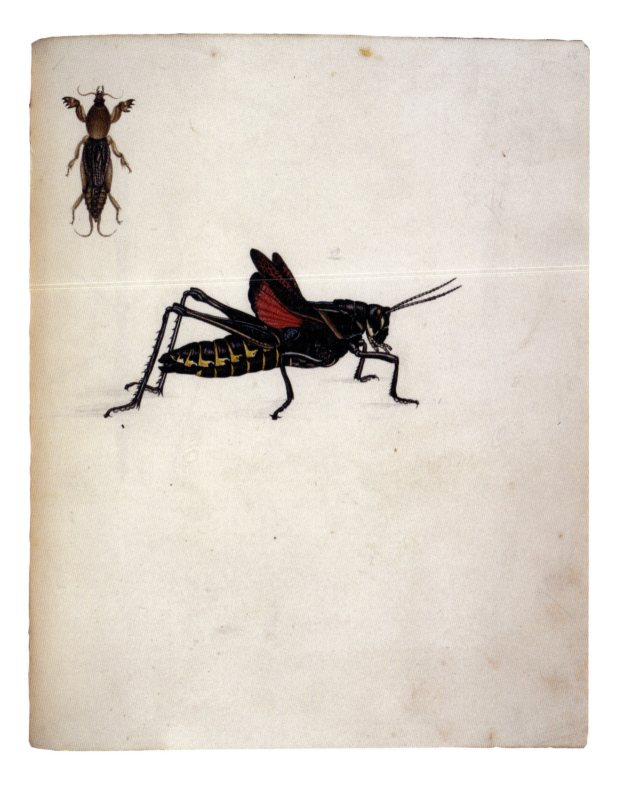

PL 43. **Walkingstick,** undetermined species.

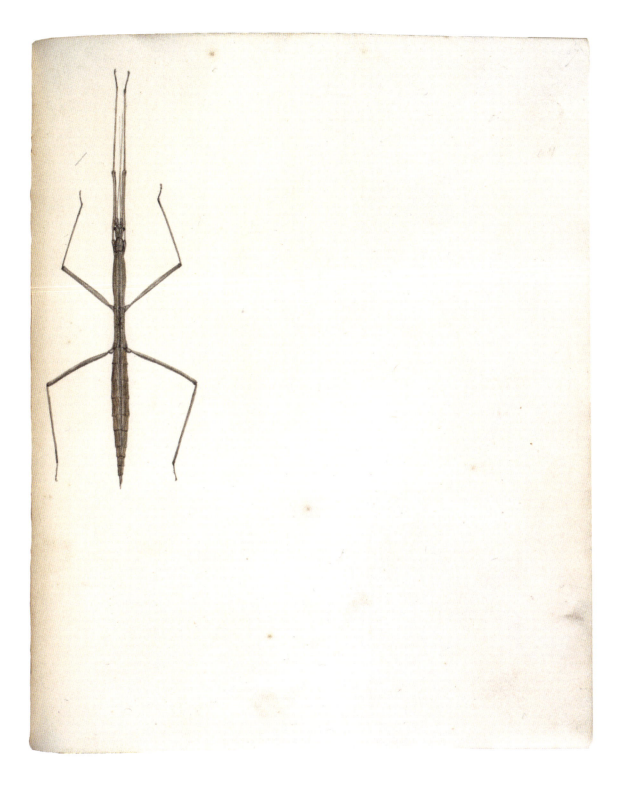

PL 44. **Carolina mantis,** *Stagmomantis carolina* (Johannson); female, gray mottled form (top); female, green form with wings spread (middle); male (bottom).

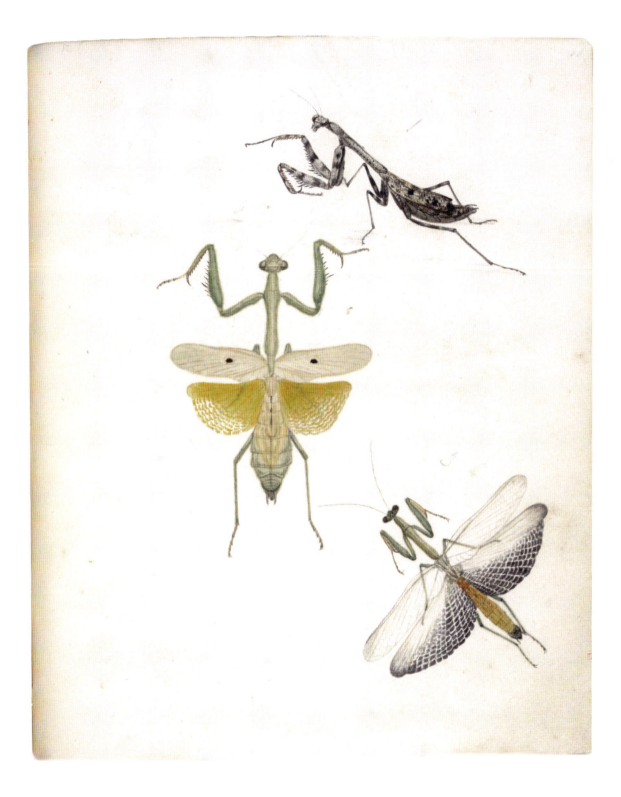

PL 45. **Organ-pipe mud dauber,** *Trypoxylon clavatum* (Say), carrying **Green lynx spider,** *Peucetia viridans* (Hentz) to tubular mud nest; larvae of the mud dauber feed on paralyzed spiders.

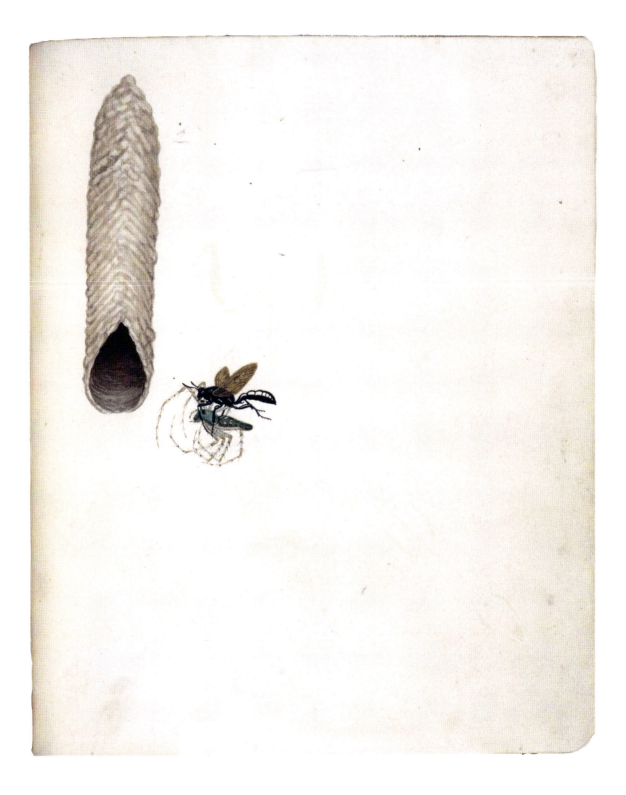

PL 46. **Walkingsticks**: *Diapheromera femorata* (Say), male (top, left); immatures (top, middle and right); female (middle); egg, enlarged 6–7 times, and actual size (bottom, left).

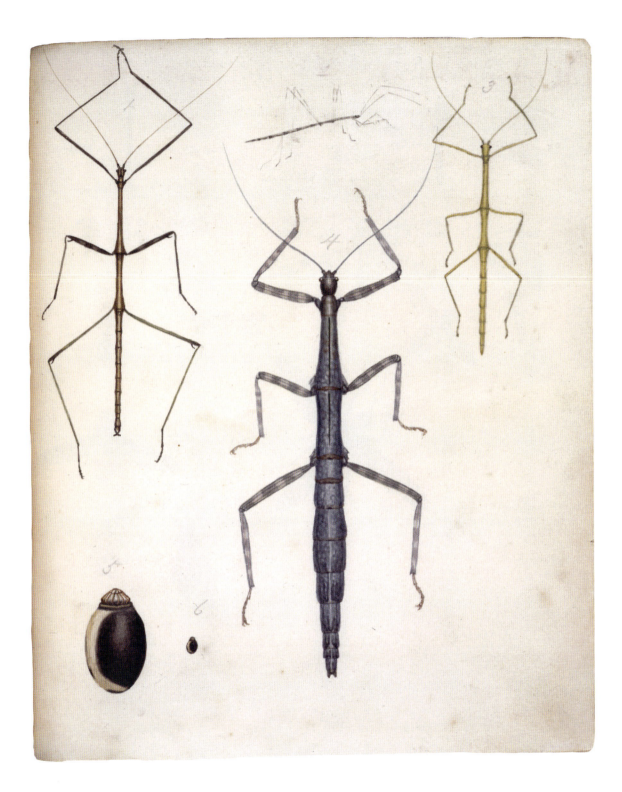

PL 47. **Antlions,** adults (first row), *Myrmeleon* species (left), *Brachynemurus* species (right); **Green lacewing,** *Abachrysa eureka* (Banks) (second row, left); **Spotted-winged antlion,** *Dendroleon obsoletum* (Say) (second row, right); **Velvet ant,** *Dasymutilla* species (third row, left); **Scorpionfly,** *Panorpa americana* (Swederus) (third row, middle); **Potter wasp,** *Eumenes* species, with mud-pot nest (third row, right); **Bee fly** (unidentified species) (fourth row, left); **Mydas fly,** *Mydas clavatus* (Drury) (fourth row, right); **Florida predatory stink bug,** *Euthyrhunchus floridanus* (Linnaeus) (fifth row, left); **Kissing bug,** *Triatoma sanguisuga* (LeConte) (fifth row, right).

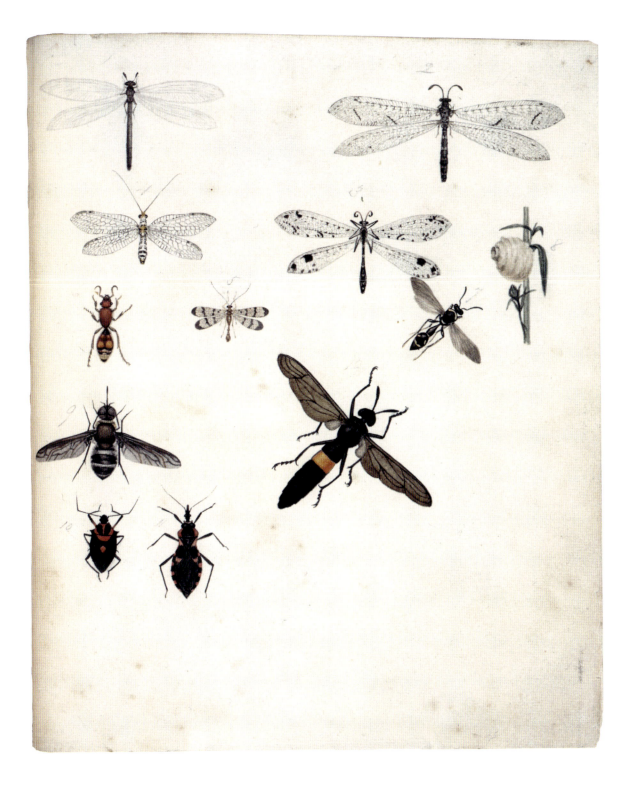

PL 48. Beetles: **Green June bug,** *Cotinus nitida* (Linnaeus) (first row, far left); **Scarab,** *Dichotomius carolinus* (Linnaeus) (first row, second from left); **Milkweed beetle,** *Tetraopes texanus* (Horn) (first row, third from left); **Elm calligrapha,** *Calligrapha scalaris* (LeConte) (first row, far right); **Squash ladybird beetle,** *Epilachna borealis* (Fabricius) (second row, left); **Longhorn beetle,** *Plinthocoelium suaveolans* (Linnaeus) (second row, middle); **Unicorn beetle,** or **Eastern Hercules beetle,** *Dynastes tityus* (Linnaeus) (second row, right); **Dung beetle,** *Phanaeus vindex* (MacLachlan) (third row, middle); **Convergent ladybird beetle,** *Hippodamia convergens* (Guérin) (third row, right); **Tile-horned prionus,** *Prionus imbricornis* (Linnaeus) (fourth row, left); **Ox beetle,** *Strategus antaeus* (Drury), on mushroom (fourth row, middle); **Stag beetle,** *Lucanus capreolus* (Fabricius) (fourth row, right); and **Stag beetle,** *Lucanus elaphus* (Fabricius) (fifth row, right).

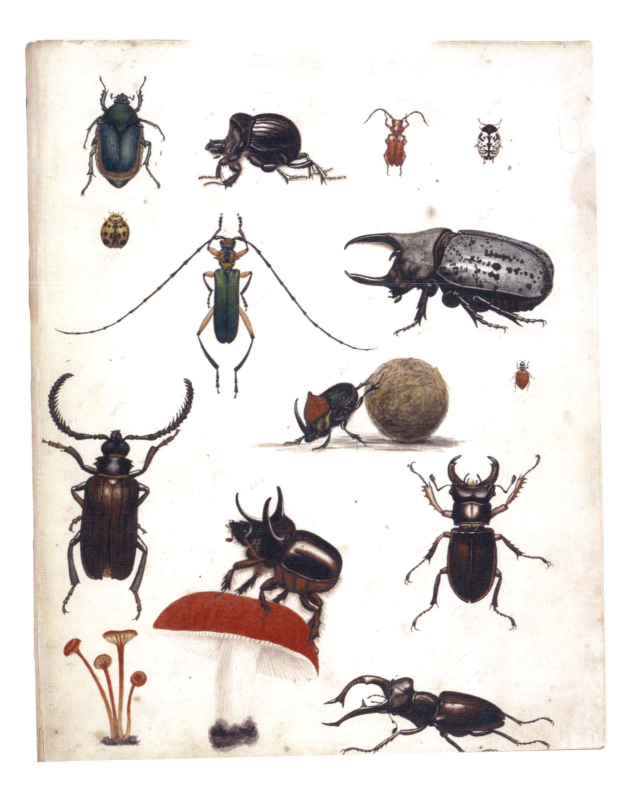

PL 49. **Large milkweed bug,** *Oncopeltus fasciatus* (Dallas) (first row, left); **Oblong-winged katydid,** *Amblycorypha oblongifolia* (DeGeer), pink form (first row, right); **Yellowjacket hover fly,** *Milesia virginiensis* (Drury) (second row, left); **Northern dusk-singing cicada,** *Tibicen auletes* (Germar), larger (second row, right); **Hieroglyphic cicada,** *Neocicada heiroglyphica* (Say), smaller (third row, right); **Pelecinid wasp,** *Pelecinus polyturator* (Drury) (third row, left); **Black horse fly,** *Tabanus atratus* (Fabricius) (third row, middle); **Scoliid wasp,** *Elis quadrinotata* (Fabricius) (fourth row, right); **Robber fly,** undetermined species (fourth row, left); **Black and yellow mud dauber,** *Sceliphron caementarium* (Drury) (fifth row, middle); and **Velvet ant,** or **Cow killer,** *Dasymutilla occidentalis* (Linnaeus), wingless female (fifth row, left) and winged male (fifth row, right).

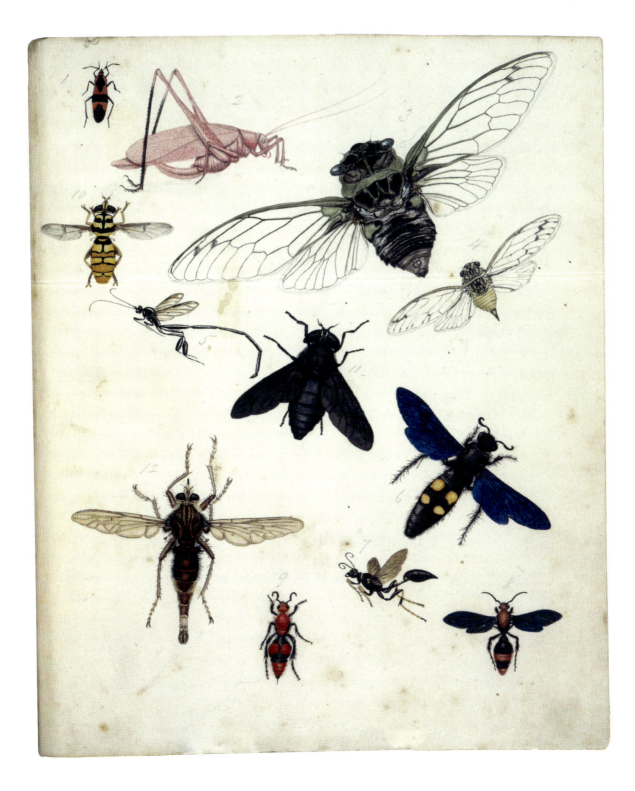

LIST OF PLATES

All plates are full-color, actual-size reproductions of the original watercolors.

PL 1. **Pipevine swallowtail,** *Battus philenor* (Linnaeus), female (top) and **Black swallowtail,** *Papilio polyxenes* (Fabricius), female (bottom); on **Trumpet creeper,** *Campsis radicans* (Linnaeus).

PL 2. **Eastern tiger swallowtail,** *Papilio glaucus* (Linnaeus), female, black form; on **Day-flower,** *Commelina erecta* (Linnaeus).

PL 3. **Palamedes swallowtail,** *Papilio palamedes* (Drury) (top) and **Tiger swallowtail,** *Papilio glaucus* (Drury) (bottom); on **Bermuda grass,** *Cynodon dactylon* (Linnaeus).

PL 4. **Zebra swallowtail,** *Eurytides marcellus* (Cramer) (left) and **Spicebush swallowtail,** *Papilio troilus* (Linnaeus) (right), on **Purple cone-flower,** *Echinaceae purpurea* (Linnaeus).

PL 5. **Giant swallowtail,** *Papilio cresphontes* (Cramer).

PL 6. **Monarch,** *Danaus plexippus* (Linnaeus); on **Indian pink,** *Spigelia marilandia* (Linnaeus).

PL 7. **Variegated fritillary,** *Euptoieta claudia* (Cramer) (left); **Gulf fritillary,** *Agraulis vanillae* (Linnaeus) (right).

PL 8. **Pearl crescent,** *Phyciodes tharos* (Drury); on **False foxglove,** *Aurelia flava* (Linnaeus).

PL 9. Sulphurs and Yellows: **Dogface,** *Zerene cesonia* (Stoll) (top, left); **Sleepy orange,** *Eurema nicippe* (Cramer) (top, right); **Cloudless sulphur,** *Phoebis sennae* (Linnaeus) (middle and middle, right); **Barred yellow,** *Eurema daira* (Godart) (bottom, left); **Little yellow,** *Eurema lisa* (Boisduval and LeConte) (bottom, middle and right).

PL 10. **Eastern comma,** *Polygonia comma* (T. Harris) (left); **Question mark,** *Polygonia interrogationis* (Fabricius) (right); on **Many-flowered zinnia,** *Zinnia multiflora* (Linnaeus).

PL 11. **Common buckeye,** *Junonia coenia* (Hübner) (left) and **Red admiral,** *Vanessa atalanta* (Linnaeus) (right); on **Butterfly pea,** *Centrosema virginianum* (Linnaeus).

PL 12. **American lady,** *Vanessa virginiensis* (Drury); on **Evening primrose,** *Oenothera grandiflora* (Linnaeus).

PL 13. **Red-spotted purple,** *Limnetis arthemis astyanax* (Fabricius); on **Indian-shot,** *Canna indica* (Linnaeus).

PL 14. **Southern pearly eye,** *Enodia portlandia* (Fabricius) (top two) and two forms of **Common wood nymph,** *Cercyonis pegala* (Fabricius) (bottom four); on **Coral bean,** *Erythrina herbacea* (Linnaeus).

PL 15. Satyrs: **Gemmed satyr,** *Cyllopsis gemma* (Hübner)

(top, left two); **Georgia satyr,** *Neonympha areolata* (J. E. Smith) (top, right two); **Little wood satyr,** *Megisto cymelea* (Cramer) (bottom, left two); **Carolina satyr,** *Hermeuptychia sosybius* (Fabricius) (bottom, right two).

PL 16. Hairstreaks, blues, and azures on **Yellow Indiangrass,** *Sorghastrum nutans* (Linnaeus): **Banded hairstreak,** *Satyrium calanus* (Hübner) (top, left); **Eastern tailed blue,** *Everes comyntas* (Godart) (top, middle); **Spring azure,** *Celastrina argiolus* (Cramer) (top, right); **Red-banded hairstreak,** *Calycopis cecrops* (Fabricius) (middle, right); and **Southern hairstreak,** *Satyrium favonius favonius* (J. E. Smith) (bottom, right).

PL 17. **Coral hairstreak,** *Satyrium titus* (Fabricius).

PL 18. Skippers, seven species on **Pencilflower,** *Stylosanthes biflora* (Linnaeus): **Silver-spotted skipper,** *Epargyreus clarus* (Cramer) (first row, left and right); **Hoary edge skipper,** *Achalarus lyciades* (Geyer) (second row, left; third row, left); **Horace's duskywing,** *Erynnis horatius* (Scudder and Burgess) (second row, middle and right); **Common checkered-skipper,** *Pyrgus communis* (Grote) (fourth row, left and middle); **Fiery skipper,** *Hylephila phyleus* (Drury), male (third row, left and middle); **Southern cloudywing,** *Thorybes bathyllus* (J. E. Smith) (fourth row, right; fifth row, right) and **Common sootywing,** *Pholisora catullus* (Fabricius) (fifth row, left and middle).

PL 19. Hawk moths: **Tobacco hornworm,** or **Carolina sphinx,** *Manduca sexta* (Linnaeus) (top, left); **Hog sphinx,** or **Virginia creeper sphinx,** *Darapsa myron* (Cramer) (top, right); **White-lined sphinx,** *Hyles lineata* (Fabricius) (middle); **Tersa sphinx,** *Xylophanes tersa* (Linnaeus) (bottom); on **Red morning-glory,** *Ipomoea coccinea* (Linnaeus).

PL 20. Hawk moths: **Banded sphinx,** *Eumorpha fasciata* (Sulzer) (top, left); **Hummingbird clearwing,** *Hemaris*

thysbe (Fabricius) (top, right); **Hermit sphinx,** *Linterneria eremitus* (Hübner) (middle, left), and **Pandorus sphinx,** *Eumorpha pandorus* (Hübner) (bottom, right); on **Cypress vine,** *Ipomoea quamoclit* (Linnaeus).

PL 21. Hawk moths: **Pink-spotted hawk moth,** *Agrius cingulatus* (Fabricius) (top, left); **Blinded sphinx,** *Paonias excaecatus* (J. E. Smith) (bottom, right).

PL 22. Giant silkworm moths: **Imperial moth,** *Eacles imperialis* (Drury) (top); **Io moth,** *Automeris io* (Fabricius) (bottom).

PL 23. **Polyphemus moth,** *Antheraea polyphemus* (Cramer), male.

PL 24. **Luna moth,** *Actias luna* (Linnaeus), male.

PL 25. Moths: **Large tolype,** *Tolype velleda* (Stoll) (top); **Spiny oakworm moth,** *Anisota stigma* (Fabricius) (bottom).

PL 26. **Giant leopard moth,** *Hypercompe scribonia* (Stoll).

PL 27. Arctiid moths and other species: **Colona moth,** *Haploa colona* (Hübner) form *fulvicosta* (first row, far left); **Reversed haploa moth,** *Haploa reversa* (Stretch) (first row, second from left); **Salt marsh moth,** *Estigmene acrea* (Drury) (first row, third from left); **Orange-patched smoky wing,** *Pyromorpha dimidiata* (Hërrich-Schaffer) (second row, far left); **Placentia tiger moth,** *Grammia placentia* (J. E. Smith) (second row, second from left); **Oblique heterocampa,** *Heterocampa oblique* (Packard), adult moth resting on plant stem (top, right); **Orange holomelina,** *Holomelina aurantiaca* (Hübner) (third row, far left); **Evergreen bagworm moth,** *Thyridopteryx ephemeraeformis* (Haworth) (third row, second from left); **Eastern tent caterpillar moth,** *Malacosoma americanum* (Fabricius), adult male (third row, far right); **Virgin tiger moth,** *Grammia virgo* (Linnaeus) (fourth row).

PL 28. Underwing moths: **Ilia underwing,** *Catocala ilia* (Cramer) (left), **Darling underwing,** *Catocala cara carissima* (Hulst) (right).

PL 29. **Red-bordered emerald,** *Nemoria lixaria* (Guenée) or **Ferguson's emerald,** *Nemoria saturiba* (Ferguson) (top, left); **Zebra conchylodes,** *Conchylodes ovulalis* (Guenée) (top, right); **Large maple spanworm moth,** *Prochoerodes lineola* (Drury) (bottom, left); and **Southern purple mint moth,** *Pyrausta laticlavia* (Grote and Robinson) (bottom, right).

PL 30. **Epione underwing,** *Catocala epione* (Drury) (top); **Bella moth,** *Utetheisa bella* (Linnaeus) (bottom).

PL 31. Dragonflies: Gomphidae female (top, left); **Common sanddragon,** *Progomphus obscurus* (Rambur), male (bottom, right); note the complex pattern of wing veins.

PL 32. Dragonflies: **Common whitetail,** *Plathemis lydia* (Drury), female (top, left); **Painted skimmer,** *Libellula semifasciata* (Burmeister), male (top, right); and **Blue corporal,** *Ladona deplanta* (Rambur), female (bottom).

PL 33. Broad-winged damselfly: **Ebony jewelwing,** *Calopteryx maculata* (Beauvois), male.

PL 34. Caterpillars, pupae, and chrysalides: **Hoary edge,** *Achalarus lyciades* (Geyer), skipper (first row, left); **Monarch,** *Danaus plexippus* (Linnaeus) (first row, right); **Variegated fritillary,** *Euptoieta claudia* (Cramer) (second row, left); **Pipevine swallowtail,** *Battus philenor* (Linnaeus) (second row, middle); **Zebra swallowtail,** *Eurytides marcellus* (Cramer) (second row, right); **Meadow fritillary,** *Boloria bellona* (Fabricius) ? (third row, left); and two **Saddleback** caterpillars, *Acharia stimulea* (Clemens), dorsal and lateral views (third row, right).

PL 35. **Spicebush swallowtail,** *Papilio troilus* (Linnaeus), caterpillar on sassafras leaf (top, left) and chrysalis (top, right); **Horace's duskywing,** skipper caterpillar, *Erynnis horatius* (Scudder and Burgess), on oak leaf (bottom, left); and **Giant swallowtail** caterpillar, *Papilio cresphontes* (Cramer) (bottom, right).

PL 36. **American lady,** *Vanessa virginiensis* (Drury), caterpillar.

PL 37. Hawk-moth caterpillars and pupae: **Tobacco hornworm,** or **Carolina sphinx,** *Manduca sexta* (Linnaeus) (top, left); **Southern pine sphinx,** *Lapara coniferarum* (J. E. Smith) (top, right); **Pink-spotted hawk moth,** *Agrius cingulatus* (Fabricius) (bottom, left); and **Banded sphinx,** *Eumorpha fasciata* (Sulzer) (bottom, right).

PL 38. Two hawk moths, caterpillars and pupae: **Tersa sphinx,** *Xylophanes tersa* (Linnaeus) (top); **White-lined sphinx,** *Hyles lineata* (Fabricius) (bottom).

PL 39. Moth caterpillars and pupae: **Io moth,** *Automeris io* (Fabricius) (top); **Luna moth,** *Actias luna* (Linnaeus) (middle); and **Imperial moth,** *Eacles imperialis* (Drury) (bottom).

PL 40. Caterpillars, pupae and cocoons: **Spiny oakworm,** *Anisota stigma* (Fabricius) on oak, with pupa (top, left); **Evergreen bagworm moth,** *Thyridopteryx ephemeraeformis* (Haworth), silken case and caterpillar (middle, right); unidentified species (bottom, left); and **Major datana,** *Datana major* (Grote and Robinson) (bottom, right).

PL 41. Caterpillars and pupae of moths: **Dubious tiger moth,** *Spilosoma dubia* (Walker) (first row, left); **Yellow-haired dagger moth,** *Acronicta impleta* (Walker) (first row, middle); **White-dotted prominent,** *Nadata gibbosa* (J. E. Smith) (first row, right); **Saltmarsh caterpillar,** *Estigmene acrea* (Drury) (second row, left); **Carpenterworm moth,**

Prionoxystus robiniae (Peck), with pupa (second row, right); Gelechiidae, unidentified, with pupa (third row, left); **Pink-striped oakworm,** *Anisota virginiensis* (Drury) (fourth row, left); **The Confederate,** *Condica vecors* (Guenée) or *C. confederata* (Grote) (fourth row, right).

PL 42. **Mole cricket,** *Neocurtilla hexadactyla* (Perty) (top); **Eastern lubber grasshopper,** *Romalea microptera* (Beauvois) (bottom).

PL 43. **Walkingstick,** undetermined species.

PL 44. **Carolina mantis,** *Stagmomantis carolina* (Johannson); female, gray mottled form (top); female, green form with wings spread (middle); male (bottom).

PL 45. **Organ-pipe mud dauber,** *Trypoxylon clavatum* (Say), carrying **Green lynx spider,** *Peucetia viridans* (Hentz) to tubular mud nest; larvae of the mud dauber feed on paralyzed spiders.

PL 46. **Walkingsticks:** *Diapheromera femorata* (Say), male (top, left); immatures (top, middle and right); female (middle); egg, enlarged 6–7 times, and actual size (bottom, left).

PL 47. **Antlions,** adults (first row), *Myrmeleon* species (left), *Brachynemurus* species (right); **Green lacewing,** *Abachrysa eureka* (Banks) (second row, left); **Spotted-winged antlion,** *Dendroleon obsoletum* (Say) (second row, right); **Velvet ant,** *Dasymutilla* species (third row, left); **Scorpionfly,** *Panorpa americana* (Swederus) (third row, middle); **Potter wasp,** *Eumenes* species, with mud-pot nest (third row, right); **Bee fly** (unidentified species) (fourth row, left); **Mydas fly,** *Mydas clavatus* (Drury) (fourth row, right); **Florida predatory stink bug,** *Euthyrhunchus floridanus* (Linnaeus) (fifth row, left); **Kissing bug,** *Triatoma sanguisuga* (LeConte) (fifth row, right).

PL 48. Beetles: **Green June bug,** *Cotinus nitida* (Linnaeus) (first row, far left); **Scarab,** *Dichotomius carolinus* (Linnaeus) (first row, second from left); **Milkweed beetle,** *Tetraopes texanus* (Horn) (first row, third from left); **Elm calligrapha,** *Calligrapha scalaris* (LeConte) (first row, far right); **Squash ladybird beetle,** *Epilachna borealis* (Fabricius) (second row, left); **Longhorn beetle,** *Plinthocoelium suaveolans* (Linnaeus) (second row, middle); **Unicorn beetle,** or **Eastern Hercules beetle,** *Dynastes tityus* (Linnaeus) (second row, right); **Dung beetle,** *Phanaeus vindex* (MacLachlan) (third row, middle); **Convergent ladybird beetle,** *Hippodamia convergens* (Guérin) (third row, right); **Tile-horned prionus,** *Prionus imbricornis* (Linnaeus) (fourth row, left); **Ox beetle,** *Strategus antaeus* (Drury), on mushroom (fourth row, middle); **Stag beetle,** *Lucanus capreolus* (Fabricius) (fourth row, right); and **Stag beetle,** *Lucanus elaphus* (Fabricius) (fifth row, right).

PL 49. **Large milkweed bug,** *Oncopeltus fasciatus* (Dallas) (first row, left); **Oblong-winged katydid,** *Amblycorypha oblongifolia* (DeGeer), pink form (first row, right); **Yellowjacket hover fly,** *Milesia virginiensis* (Drury) (second row, left); **Northern dusk-singing cicada,** *Tibicen auletes* (Germar), larger (second row, right); **Hieroglyphic cicada,** *Neocicada heiroglyphica* (Say), smaller (third row, right); **Pelecinid wasp,** *Pelecinus polyturator* (Drury) (third row, left); **Black horse fly,** *Tabanus atratus* (Fabricius) (third row, middle); **Scoliid wasp,** *Elis quadrinotata* (Fabricius) (fourth row, right); **Robber fly,** undetermined species (fourth row, left); **Black and yellow mud dauber,** *Sceliphron caementarium* (Drury) (fifth row, middle); and **Velvet ant,** or **Cow killer,** *Dasymutilla occidentalis* (Linnaeus), wingless female (fifth row, left) and winged male (fifth row, right).